Books are to be returned on or before
the last date bel

Intelligence
New British Art 2000

Virginia Button and Charles Esche

With contributions by Charlie Gere and Ralph Rugoff

TATE PUBLISHING

cover: Hilary Lloyd,
Monika 2000, production still
(detail). Courtesy the artist

frontispiece (fig.1):
Graham Gussin, *Spill* 1999,
16mm film still (detail).
Artist's collection

Published by order of
Tate Trustees 2000
on the occasion of the
exhibition at Tate Britain,
6 July—24 September 2000

ISBN 1 85437 327 7

A catalogue record for this
publication is available from
the British Library

Published by Tate Gallery
Publishing Limited, Millbank,
London SW1P 4RG
Editor: Judith Severne
Production: Time Holton and
Susan Lawrie

Designed by Peter B. Willberg
at Clarendon Road Studio
Printed and bound in Great
Britain by Balding + Mansell,
Norwich

Intelligence is the first in a new series
of exhibitions of contemporary art to be
held every three years at Tate Britain.
Entitled *New British Art*, the series will
regularly present some of the best recent
and emerging art in Britain. Each exhibi-
tion will take and make its own distinctive
curatorial perspective. This year's show,
the largest ever mounted by Tate, has been
curated by Virginia Button, Senior Curator
at Tate Britain, and Charles Esche, the
independent curator and writer based in
Edinburgh. Bringing together the work of
twenty-two artists based in Britain, *Intel-
ligence* has developed over the last two
years through wide discussion and extensive
visits to studios and exhibitions. It is
in every sense a collaborative project,
between curators, artists, and — most
importantly — visitors to the exhibition,
exploring art's agency in our engagement
with the contemporary world.

Today, new technologies allow vast quan-
tities of data to be assembled, processed
and transmitted at ever-increasing speeds,
with effects on our lives that are only
beginning to become apparent: there is some
anxiety that the sheer volume and ubiquity
of information is adding little to the sum

of human wisdom or creativity, and may even be drowning out our capacity for thought. What is important, of course, is not information in itself but the ways in which it can be applied to our world and our ways of understanding — in short, the intelligence with which we use it. In this sense artists are, and have long been, among the most important 'intelligence agents' at large in society. Uniting the artists in this exhibition is, above all, their invitation to viewers to investigate their work and arrive at their own conclusions, recognising that the significance of their art arises from a dialogue. From the outset, the curators aimed to place the emphasis on the audience's experience and to draw attention to the crucial role of conversation — both between generations of artists and between the viewer and the works.

Carolyn Kerr, Curator at Tate Britain, has co-ordinated the design and installation of the exhibition, working closely with the curatorial team and with Adam Caruso of the architectural practice Caruso St John, which has risen admirably to the challenge of presenting such diverse and forceful work within the twenty-one galleries that comprise Millbank's 1979 north-east extension. The exhibition's layout aims to emulate the lucidity and ease of orientation of a familiar nineteenth-century gallery, with a simplicity that allows the works to be seen on their own terms. The catalogue, beautifully designed by Peter B. Willberg, includes important contributions by the critic and curator Ralph Rugoff and by Charlie Gere of Birkbeck College, London.

We owe, of course, our largest debt to the artists themselves, who have each shown great commitment to the concept of the exhibition and whose collaboration at every stage has been invaluable. We are also grateful to the galleries representing them, who have assisted in many aspects of this project, and to the Collezione Prada for lending to the exhibition. I hope that all those who have contributed so generously have enjoyed the experience of working with those at Tate Britain, in its inaugural year, and particularly with Virginia Button and Charles Esche — to whom profound thanks are due for the creativity and dedication they applied to *Intelligence* throughout.

Stephen Deuchar *Director, Tate Britain*

ACKNOWLEDGEMENTS

Of its very nature, this project has depended on the collaboration and goodwill of numerous people. We are especially grateful to the participating artists for their enthusiasm and commitment, and to the many artists whom we visited in the process of selecting the exhibition: discussions with all of them helped shape *Intelligence*. In particular we would like to thank Michael Craig-Martin, William Furlong, Liam Gillick, Susan Hiller, Alan Johnston, Julian Opie, Permindar Kaur and Mark Wallinger for the conversations we have shared with them over the last two years. We would also like to thank Nick Serota, Stephen Deuchar, Sheena Wagstaff, Sandy Nairne, Jane Warrilow and Tom Scott for their continued support.

We would like to express our appreciation to all those who have helped to present the exhibition: Ralph Rugoff and Charlie Gere for their catalogue contributions; Peter B. Willberg for his catalogue and leaflet designs; Adam Caruso and Silvia Ullmayer for clarifying a complex layout and re-designing the orientation spaces of the 1979 extension; graphic designer Philip Miles and his team for all their work.

Many individuals and institutions have generously lent their support to *Intelligence*, and we would like to thank all those who have enabled the work in this show to be made, exhibited and promoted to a wider audience, including the artists' representatives, supporters, collectors, technicians and assistants. Our special thanks go to James Lingwood and Artangel, George Goldsmith and Unicol, Illuminations and Channel Four Television.

We would also like to acknowledge our debt to the many Tate staff who have helped bring the project to fruition. We are especially grateful to the Tate Britain exhibition team — Dafydd Lewis, Rachel Meredith and Katharine Stout, led by Carolyn Kerr — who have been involved in all aspects of making the exhibition. Special thanks also to Joanna Banham, Sarah Briggs, John Bracken, Jane Brehony, Ray Burns, Dave Dance, Mark Edwards, Sarah Greenberg, Gemma Haley, Karen Hall, Mikei Hall, Roy Hayes, Jackie Heuman, Ben Luke, Sue MacDairmid, Jehannine Mauduech, Ben Rawlingson-Plant, Jane Richards, Clare Storey, Piers Townshend and the Art Handling team for all their efforts in realising *Intelligence*.

Virginia Button and Charles Esche

INTELLIGENCE IS THE GREAT APHRODISIAC[1]
VIRGINIA BUTTON AND CHARLES ESCHE

The English might be said to have a problem with intelligence. The idea of an intellectual class, as opposed to a land-owning or trading one, has never become rooted here in the way that it has in mainland Europe and other societies who cultivate their 'intellectuals'. In fact, English philosophical life has often received its greatest intellectual contribution in the shape of immigrants from other parts of the British Isles, from Europe and from the former British Empire. One reason might be the overt inequalities of the education system, which have historically limited the intelligentsia to those who are upper class or wealthy. Another might be a certain pragmatism born out of the hybrid nation that became England in the high middle ages — absolutes giving way to practical living patterns of toleration, generosity and guardianship of private space.

Whatever the reason, as we begin the new century and look forward to a proclaimed age of information, wealth and knowledge-based economies, it is likely that the definition of, and aspiration towards, intelligence will transform rapidly. Technological developments are contingent on a brighter, more flexible consumer class.

Easy personal communication requires a sharpness of mind and body. The birth of new and necessary oppositional strategies to corporate government and global capital will require us to think in different ways. These changes may be caused by developments in economic materialism, but art has crucial opinions to express about them. Indeed, if not in art then where is the questioning going to begin? This is the starting point for *Intelligence*, which launches *New British Art*, a series of exhibitions of contemporary art from the United Kingdom to be held every three years at Tate Britain.

The title and the ideas came from many studio visits and discussions with artists. Our task was to select a show of new and recent British art and initially we spent much time looking at work and artists that had come to our attention over the past two years. The experience brought us fairly rapidly to certain conclusions. The idea of a common cultural inheritance that could define art in terms of its British origin was bogus. The cultural idea of 'Britishness' is itself a fairly recent creation, and one that cannot accommodate the ambitions, influences and inspirations of the

current generation of artists living here. Certain communities of artists, specifically in London and central Scotland, are energetically collaborating with and learning from one another. But these communities do not cease their activities at the frontiers of Britain. They take part in the international art world, out of economic necessity in part, but crucially as a way to exchange ideas and find role models, networks of supporters and further collaborators. The situation is more a tale of concentrated locations than of nations — places where things can happen in art, where people meet and finance is provided. London is an important centre now and probably will remain so. For the rest of the UK it is a question of whether the will exists to take part in the international art world, both on the part of artists who live there and the affluent society of which they are a part. Scotland, having its own dialogue with its past, is able to sustain a contemporary art scene in Edinburgh and Glasgow and will hopefully prosper under the new and changing political dispensation. We may hope that other cities will continue to grow in confidence and commitment towards contemporary art, each with

its own internationalist vision rather than one focused on any notion of British art.

Clearly any idea of Britain as a unitary culture is unsustainable. Recent political changes have only reflected an already existing heterogenous culture in the various parts of the United Kingdom. Nevertheless, it became clear to us during our research that all the artists were, in very different ways, keen to develop a dialogue with their audience. Although this desire is visible in many places abroad, it seems particularly pronounced here. There might be a number of reasons for this, but undoubtedly the attitude of the so-called 'yBa' (young British artist) generation in circumventing the existing art system and going straight to the audience and media has had a major impact. By creating, almost from nothing, a mass audience for contemporary art, they have allowed artists of all generations to feel confident in their social role and courageous enough to try to speak to as broad an audience as possible. This change in the reception of art in Britain during the 1990s has now become established in such events as the Turner Prize, and exhibitions, notably *Sensation* held at the Royal Academy in 1997. It is an

fig.2 Hilary Lloyd, *Broad Walk* 1994, video still.
Courtesy the artist

atmosphere that allows the artists in *Intelligence* to produce their work with a knowledge that there will be an interested public with whom they can communicate.

As our thinking developed along these lines, the metaphor of investigation as a basic methodology for artists making new work began to make sense. This concept became not so much a theme as a way to focus on the dynamic relationship between artists and their audiences. Investigation has a particular history and popular mythology in the accounts of private detectives and secret agents that makes it an open and inviting concept for a viewer looking at contemporary art. Furthermore, it describes one of the most obvious facts about much of the most exciting contemporary art we were seeing. The artwork itself is subject to the processes of its production by the artist only as the beginning of a journey towards meaning and significance. Its interpretation is determined just as much through the processes of insight and translation in the eyes and mind of the viewer. It is this negotiation that lies at the heart of an apparent uncertainty or ambiguity in much contemporary work. Perhaps this does not suit a broad cultural

expectation of confident certainties built on the approach of politicians, economists or media celebrities, but it is the basis for a thoughtful, self-critical society. For art to encourage this would seem to be one of its primary aspirations.

From the artists' point of view investigations are rife in the works featured in *Intelligence* — from the collected evidence of small-town skills and passions in the *Folk archive* of Jeremy Deller and Alan Kane; Hilary Lloyd's video portraits of individuals encountered in her daily life; Susan Hiller's trawling of the internet; to Tacita Dean's discovery of a decaying wreck in the Cayman Islands. But the term 'investigation' alone does not do justice to the relationship between artist and viewer. It is too static and cool to describe fully the activities waiting to be discovered here. It suggests the idea of a process of discovery but directs it towards a final conclusion in which everything is revealed. Yet art must be a different experience for each viewer, collective meanings being made of the sum of many individual opinions, both of which may change dramatically over time. 'Investigation' does not speak about how that process might be encouraged. What

faculties are brought into play? Are the 'rules of the game' already written, or do they change through the process of looking? Most significantly, how does art actually operate — not as a utopian model, but as an objective fact in the face of artists and visitors gathered in a gallery? By asking these questions, we moved from thoughts about investigation to the idea of intelligence. Michel Foucault has written:

> What distinguishes thought is that it is something quite different from the set of representations that underlies a certain behaviour; it is also something quite different from the domain of attitudes that can determine this behaviour. Thought is not what inhabits a certain conduct and gives it its meaning; rather, it is what allows one to step back from this way of acting or reacting, to present it to oneself as an object of thought and question it as to its meaning, its conditions, and its goals. Thought is freedom in relation to what one does, the motion by which one detaches oneself from it, establishes it as an object, and reflects on it as a problem.[2]

There is certainly a distinction between thought and intelligence. It might be suggested that intelligence is a generalist inquiry into the nature of things, and thought descriptive of a specific action. Nevertheless, thought and intelligence are sufficiently closely related to justify the paraphrasing of the above statement by Foucault to read 'intelligence is freedom in relation to what one does'. If this is so, then it chimes loudly with the desires of our times. Freedom is the mechanism through which our wishes and hopes are currently defined, usually expressed through the ideology of free choice in the marketplace. However, allied to thought or intelligence, freedom provides a map of a future condition, one in which society might move beyond an obsession with the accumulation of material goods towards a countervailing value placed on ideas and discourse. This is arguably the direction in which Conceptual art and its successors since the early 1960s have been pointing. It is certainly the ambition of the exhibition to raise this question and to put forward an argument for art as a instrument to model new codes of value and behaviour in the future. In the age of the internet, the

network or web is replacing linear progression as a model for capitalist innovation and economic analysis. In turn, the agility of intelligence, in contrast to the repetitive exercise of muscular energy, appears to be an apt human parallel. We would like to suggest that art itself is acting rather like an intelligence mechanism through which experiences and ideas can be tested. The exhibition title therefore becomes a trigger to fire discussion not only about the selected work but also about the broader territory of art's engagement with the world.

Now, if intelligence is freedom, then to focus on intellectual criteria alone would be incorrect. Neither individual nor collective intelligence is restricted solely to matters of the mind. Indeed, this presumes a Cartesian split between mind and body that contemporary science has made impossible to maintain. Instead, intelligence implies all the mechanisms of translation from the perceived external phenomena into some kind of internal comprehension. Marcel Duchamp, for whom intelligence was a crucial concept, defined his own understanding of the word in this way. 'I understand [the] idea of intelligence as large, drawn-out, extended,

inflated if you wish.'[3] Recent research by the neuro-biologist Samir Zeki also throws an interesting light on the relationship between perception and understanding through the agency of intelligence:

> We see in order to be able to acquire knowledge about the world … Vision just happens to be the most efficient mechanism for acquiring knowledge and it extends our capacity to do so almost infinitely … Vision is therefore an active process, not the passive one we have for long imagined it to be. Even the most elementary kind of vision, such as that of a tree, or a square, or a straight line is an active process. A modern neurobiologist would, or at least should, approve heartily of Henri Matisse's statement that 'Seeing is already a creative operation, one that demands an effort'.[4]

If the simple act of seeing is an active process, then intelligence invades even this most instinctive and primary of senses. Such visual or, more accurately, physical intelligence is explored in the work of a number of the artists here. Look,

fig.3 Michael Craig-Martin, *ModernStarts: Things* 1999–2000,
site-specific wall painting at the Museum of Modern Art,
New York, 1999–2000. Courtesy the artist and Waddington
Galleries

for instance, at Alan Johnston's wall draw-
ings, which, almost invisible at first
sight, become more and more insistent the
longer they are considered. Michael Craig-
Martin's very different wall paintings
also negotiate a territory between initial
recognition and gradual reappraisal of
the image as the relationship between the
depicted objects and the nature of the
depictions complicates a simple understand-
ing. The same analysis might equally apply
to works in other media such as Sarah
Lucas's *Life's a Drag Organs* or the dis-
tance between sound and image in *Eyelashes*
by Jaki Irvine. All these negotiations
adopt a similar method of constructing
meaning through subjective visual or sensu-
ous experience, something dependent upon an
awareness of the active nature of looking.
Of course, it is the prerogative of the
viewer to exercise his or her intelligence
in this way, though the pleasures to be
found by doing so are not only in a more
generous intimacy with art, but also in the
training of a more acute critical eye.

Intelligence is intended to occupy such a
critical space, where the viewer and artist
meet on fairly equal terms. They are both
attempting to come to terms with, and make

sense of, material that is by its nature
slippery and imprecise. Duchamp again cap-
tured this point succinctly in the early
part of the last century. 'The creative act
is not performed by the artist alone; the
spectator brings the work in contact with
the external world by deciphering and
interpreting its inner qualifications and
thus adds his contribution to the creative
act.' This quotation introduces the diffi-
cult concept of interpretation, around
which another essay could be written. For
our purposes, the central tenet to be taken
from recent interpretative studies is that
the constant flow of time relates closely
to the fluidity of being and understanding.
As such, experience becomes subjective and
both time and space are shaped by the indi-
vidual imagination. In this world, which
has been described as much by quantum
physicists as by philosophers and artists,
everyone has a right to their own world-
view, in which they create their own time,
memories and meanings for things.

Under these conditions, we could ask what
might be the purpose of a contemporary
group exhibition? One answer is perhaps
simply to provide a comfortable entry point
for these 'creative acts' to occur. *The*

fig.4 Liam Gillick, *Big Conference Centre Limitation Screen*, 1998. Installation at Robert Prime Gallery, London 1998. Courtesy the artist and Corvi-Mora

Pitch, by Mark Lewis, which comes to stand for the significance of the audience (the extras) playing their part alongside the artist, is a memorable introduction. Taken further, it might allow the nature of each personal experience to loop back into the exhibition through opinions and ideas gained during a visit. Bob and Roberta Smith's *STOP IT WRITE NOW!* carries something of this responsibility. The process could also inform the discussions that visitors might take with them into the rest of Tate Britain's galleries, discussions hopefully prompted by the manipulated conversations between the artists that animate the final work in the show by William Furlong.

Two other works besides Furlong's suggest models for looking at the exhibition as a whole. The first room in the exhibition contains an installation by Julian Opie that mimics the structure of the museum experience and particularly the other display rooms elsewhere in the Tate. Walls hung with digitally generated paintings of familiar genres such as still lifes, nudes and portraits dominate the space, while in the centre a small group of semi-abstract, digitised viewers gather to consider their response. Opie's work points to a confusion between subject and object, perceiver and perceived, where identities blend into one another. Representations of the audience are placed in the centre, to be viewed by the visitors, but they are also engaged in their own acts of looking. The construction of meaning is doubled, and attempts to weave the pictorial images together come up against the presence of these proto-viewers as symbols of other interpretations and intelligences. Another work, placed towards the middle of the show, reinforces this intention. Liam Gillick's structures allude to existing spaces where different forms of decision-making and power-broking are executed. They serve as fictional spaces for the viewer to inhabit, similar to Opie's paintings, though here, Gillick attempts to make imaginative connections between the artists themselves. Viewers are therefore invited to become decisive players in recreating any imposed narrative or interpretation.

These three works can be said to exist as both individual expressions of the artists and as tools with which to interpret and investigate the exhibition. Intelligence itself could also be viewed as a tool, indeed the greatest human tool, for coming

to terms with phenomena in the world. Applied to an exhibition, this notion of intelligence places responsibility with visitors to come to terms with the work for themselves. Yet it also allows the variegated form of those responses full leeway. Having established that intelligence is not only an intellectual activity, its emotional, spiritual and aesthetic qualities can be discovered in the work of artists in the exhibition and brought to bear by the viewers. Such a multilevel register of expression might be seen as a strategy to avoid the rapid emptying out of meaning that is so characteristic of our time. It is intended to encourage a longer and deeper exploration of the work that ultimately allows the experience to translate into the viewer's own world, perhaps to transform his or her existing assumptions.

The title *Intelligence* also offers another reading that suggests different models for the activity of the visitor. The term calls up a reference to military intelligence and the secret service, a British literary trope employed from Joseph Conrad to Ian Fleming and beyond. 'Intelligence' in these terms equates to secret information and, crucially, information that has been processed and interpreted so that its meaning can be shared and acted upon. For some of the artists, it provides a beautiful allegory of their own modus operandi. It is redolent of clandestine meetings over coded messages, fortuitous discoveries, swift exchanges and long periods of quiet observation. Moreover, the secret agent, who must avow allegiance to two opposed truths at the same time, necessarily understands the worldview of the other side. This sympathy for the other is something that many interesting contemporary artists have consistently sought in the last decade. It emerges through the emotional intelligence of the work by Oladélé Ajiboyé Bamgboyé, or Gillian Wearing as well as the more overt encounters between cultures that characterises the selected pieces of Yinka Shonibare or Jeremy Deller and Alan Kane. Tom Lawson, in challenging the work of overtly political artists from the early 1980s, summed up the artistic potential of the secret agent's role:

Better then the strategy of the spy, the infiltrator, the undercover agent who can make himself acceptable to society while

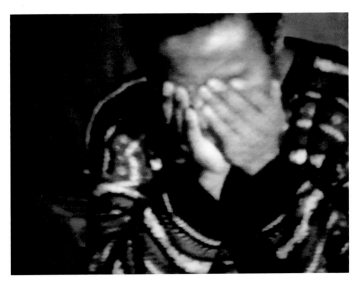

fig.5 Oladélé Ajiboyé Bamgboyé, *Spells for Beginners*
1994/2000, video still. Courtesy the artist

all the while representing disorder.
Master of the double bluff, he is able to
infiltrate the centres of power in order
to undermine the structure from within.
An art of representation, a flirtation
with misrepresentation. An ambiguous art
which seems to flatter the situation
which supports it while undermining it.
Sweetly arbitrary, art which appears
attractively irrational, but which turns
out to be coldly rational; art which
looks distant but is deeply felt.[5]

How true is this also for the museum visi-
tor? To be a spy in the house of art would
be to observe its goings-on with some
ambivalence, to ask unsolicited questions
and doubt its outward motivations. At the
same time, some aspects could be turned to
one's advantage, individual ideas isolated
and secrets exchanged. It is, all in all,
a fine role, though one that benefits from
eliminating zeal for a particular cause. It
is the necessary independence of thought
and the interpretative strategy that it
implies that makes the spy (or perhaps the
agent provocateur) the perfect role model
for the visitor to an exhibition of contem-
porary art.

1 Quoted in William Marling, *William Carlos Williams and the
Painters*, Athens, Ohio 1982, p.66.
2 Michel Foucault, 'Polemics, Politics, and Problematizations:
An Interview', May 1984, in *The Foucault Reader*, ed. Paul
Rabinow, London 1984, p.388.
3 Marcel Duchamp in Pierre Cabanne, *Dialogues with Marcel
Duchamp*, London 1971, p.16.
4 Samir Zeki, *Inner Vision*, Oxford 1999, pp.4–6.
5 Tom Lawson, 'Spys and Watchmen', *Cover*, no.3, New York 1981,
p.17.

THE WORK OF ART IN THE AGE OF THE GENERAL INTELLECT

CHARLIE GERE

The name of a contemporary art show often constitutes a kind of manifesto. *Sensation* at the Royal Academy (1997) not only captured the vivid excitement generated by the work, but ended up as a kind of self-fulfilling prophecy. *Freeze* (1988), the show of young British artists curated by Damien Hirst in an East End warehouse, was almost parodic in its invocation of the street cool that would later define Brit Art. Going further back to 1976, the ICA show *Prostitution* succeeded in provoking the outrage intended by its title, as well as anticipating the later provocations to be unleashed by the burgeoning punk scene.

What then might we expect from *Intelligence*? Since the term is usually taken to refer to the faculty of understanding or intellect, *Intelligence* at first perhaps suggests a focus on the idea of art as a process of intellectual exploration and interpretation. But 'intelligence' has other more specific meanings. It can of course refer to knowledge or information obtained secretly for military or political purposes. It was partly the needs of such intelligence in the Second World War that led to the development of 'intelligent machines', computers. Such intelligent machinery is now ubiquitous, having entered almost every aspect of our lives. In particular it is crucial for the operations of globalised capital, enabling the production, circulation and consumption of commodities throughout the world.

Intelligence, whether programmed into machines or embodied in human labour, is the means by which the complexities of our contemporary 'information society' are negotiated. The foundations of such a society were laid when, after the Second World War, 'information theory' was developed to deal with the technical issues involved in enabling the efficient and unambiguous transmission and reception of messages in telecommunications. Despite its technical basis, this theory was adopted as a model of desirable communicativity in diverse areas including literature, the arts and social theory. Along with fashionable notions of cybernetics and systems, it informed and influenced many attempts to develop new ways of understanding human social relations and other phenomena, as well as being crucial for those working in computing and networking. Its importance for the cultural zeitgeist was confirmed in 1970 when the Museum of Modern Art in New

York put on a show called *Information*, featuring the work of contemporary avant-garde artists from all over the world working in a variety of media, including film, photography, video and other then unconventional means. One of the intentions of the show was to reflect the 'intellectual exchange' and 'international community of artists' made possible in a culture 'considerably altered by communications systems'. In his catalogue essay the curator, Kynaston McShine, suggested that the possibilities offered by communications systems and new media would enable artists to 'create an art that reaches out to an audience larger than that which has been interested in contemporary art in the last few decades'.[1]

The emphasis placed by McShine on the importance of the technologies of communication and information not only reflected the contemporary situation, but was prescient about future developments. Though obviously he was aware of the power of television, advertising and the mass media, he could not have guessed at other more momentous developments that would dramatically alter society. When *Information* opened the internet was barely a year old, and inaccessible to all but a few in the military and academia; the personal computer was several years away from being developed. Terms such as 'information economy', 'age of information' and 'information society' were not yet in wide circulation. But it must have been clear that changes were taking place, and that information communication technologies were involved.

Over the next two decades, every aspect of life in developed counties was overhauled in the name of a deregulated, globalised capitalism, underpinned by conservative and neo-liberal politics; this was facilitated by prodigious developments in computing and telecommunications. The 1980s brought unparalleled access to information and to the means of communication through the expansion of television networks, telephony, personal computers, the internet and, later, the world wide web.

But the advent of the information society did not bring with it the increased possibilities for understanding it might once have promised. McShine had already noted in 1970 that 'The public is constantly bombarded with strong visual imagery … an artist certainly cannot compete with a man on the moon in the living room'.[2] The consequent

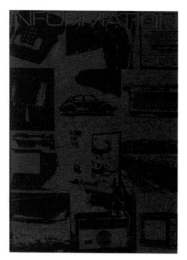

fig.6 Cover of the exhibition
catalogue, *Information*.
The Museum of Modern Art, New
York 1970. Photograph courtesy
The Museum of Modern Art, New
York

developments in information and communications made it even harder for artists to compete with other visual and informational stimuli, and even to distinguish what they did from other activities, despite McShine's hopes for larger audiences.

The coming of the information society brought about what Gianni Vattimo has described as a 'generalised aesthetisation' of the social and the political, making it difficult to distinguish the creativity involved in art from that employed in advertising or electioneering.[3] One reaction to the hypersaturation of the world by signs was to participate fully in this situation, refusing any meaningful distinction between art and other forms of sign-making, a move made by artists from Andy Warhol onwards. A different artistic strategy was a refusal of the possibility of meaningful communication (paralleled in contemporary philosophical developments, such as Poststructuralism). This involved a concentration on the autonomy and freeplay of the signifier, the use of the 'randomly heterogenous and fragmentary and the aleatory', the 'schizophrenic' experience of language and the world, and the flattening of space. Both these moves were

corralled under the name 'Postmodernism'.[4] (Interestingly many of the artists involved in *Information* were making work that would later be described as postmodernist.) For the cultural critic Fredric Jameson, postmodernism was a melancholy acknowledgement of the triumph of capitalism, in which the last enclaves of resistance or autonomy succumbed to commodification.[5] With this triumph came the end of the utopianism that had constituted a central element of artistic modernism, or at least its attenuation into obscurity. The idea of the artist as an avant-garde, literally an advance guard, of a future utopian society, no longer seemed tenable. This appeared to be confirmed by the tearing down of the Berlin Wall in 1989, and the subsequent collapse of the Soviet Union. History, according to the triumphalists, was at an end. With no history there could be no utopia other than that — already in place and continually expanding — of capitalism.

But with new realities come new possibilities. The recent developments in information technology and their relationship to a restructured capitalism were anticipated by Karl Marx in his set of notebooks, written in the 1850s and published in the

1930s under the title *Grundrisse*.[6] In a now famous passage known as 'The Fragment on Machines' Marx suggested that the general social knowledge or collective intelligence of a society — or what he described as the 'general intellect' — of a given period can be embodied in machines as well as humans, and with the burgeoning development of automation, is likely to be so. Marx believed with optimism that the increasing embodiment of intelligence in fixed capital — machines — would bring about a fatal contradiction in capitalism that would inevitably usher in an era of Communism. More recently, some Marxist theorists have chosen to interpret the concept of the 'general intellect' as that diffusion of intellectual knowledge through society as a whole, and as a necessary aspect of the technological development in relation to the restructuring of capital. Some began to talk of the 'mass intellectual' or 'diffused intellectual' to describe those whose living labour consists in 'creativity' and 'social communication', sometimes known as 'immaterial labour'.[7] These terms are used to describe seemingly different kinds of workers, such as computer programmers, those working in automated 'cybernetic'

factories, graphic designers, advertising copywriters, teachers and social workers.

The emergence of the general intellect has brought with it new possibilities for resistance. Once in control of the collective and intellectual processes of production, labour can no longer be mastered by capitalism. Capital can only recuperate and subdue social communication, and control labour from the outside after having acknowledged and even stimulated its creativity and far-reaching intelligence. A case in point is the internet, which relies on structures of labour, such as programming and design. These involve high degrees of social co-operation and cannot be controlled in the same manner as older forms of work. The continuing conflicts fought through and over the internet concerning issues of freedom of expression, freedom of access, and privacy, among others, demonstrate the capacity of labour to resist recuperation and control and to assert large degrees of autonomy. This is further shown in the use of such technology in recent movements aimed at resisting the hegemony of globalised capital, and proposing alternatives. In particular the internet and the world wide web have been

exploited by groups such as the Zapatistas in Southern Mexico, Greenpeace, Reclaim the Streets and many others. As the events surrounding the World Trade Organisation Conference in Seattle in 1999 showed, these technologies can enable complex coordination of different groups without the imposition of hierarchical control.

Alongside these movements new forms of politically engaged art practice have emerged, including the work of ACT-UP, Gran Fury, the Guerrilla Girls, the Luther Blissett Project, the Critical Art Ensemble and others, all of which exploit different forms of media, including the internet, to resist the repressive and limiting effects of power. Thus the aesthetisation of the social, which accompanied the coming of the information age, has necessitated the socialisation of aesthetic practice, and with it the potential for autonomous creative expression and political resistance beyond the needs of capital.

What might this mean for the contemporary art exhibition? Such events have become ritualised components of a friction-free circuit of institutionalised provocation and tabloid sensation. Apart from the publicity and outrage generated through this circuit, the practice of art has little relevance for anyone outside of the small group of artists, curators, dealers, collectors, academics and critics that constitute the art world. This is bound up with a refusal to consider art other than in the ironic, self-reflexive terms in which it presents itself. Contemporary art exhibitions seem largely devoid of intent of any sort, other than that of sensational display. This is regrettable, not least because much recent contemporary art is clearly the product of complex political and intellectual understanding. Clearly, there are not easy solutions to the problems of the institutional display of contemporary art. But changing the terms in which such displays are presented might enable a move beyond the sterility of the present situation. This is, as I understand it, the intention of *Intelligence*. It reinstates the idea of art being necessarily difficult, requiring the exercise of intelligence on the part of both the artist and the audience. This is a return to the critic Theodor Adorno's aesthetic theory, in which the difficulties presented by the work of art and the concomitant necessity of exercising critical intelligence, are

the means by which it can avoid commodification and cooption into the 'culture industry'.[8]

For Adorno the crucial term is 'autonomy'. By this, he refers to the status of art as an independent realm in society, able to expose societal wounds and imagine alternative arrangements. Adorno's concept of autonomous art has been criticised for a number of reasons, not least for being elitist. But recently, the idea of autonomy has taken on new and more positive meanings, as we have seen above. The technological developments concomitant with recent capitalist restructuring has opened up spaces for the exercise of autonomy as a form of resistance. This makes possible the renewing of the compact between the artistic avant-garde and politics. This would not be a return to the avant-garde as an advanced guard of progressive culture leading the assault on the bourgeois values of a capitalist society, but instead as a movement leading an 'exodus' away from capitalism and towards a general strategy of autonomy, involving refusal and defection from capitalist social relations. This is what 'intelligence' might mean as a manifesto. It is the intellectual capacity to realise the expanded potential offered by new technological and social assemblages. It is also the knowledge that this potential far exceeds the limitations such assemblages presuppose. The artist as an autonomous figure, interpreting and questioning the world, and finding unforeseen possibilities within it, is emblematic of a potential new order, in which the intellectual capabilities unleashed by the needs of capital become sources of liberation from a capitalism whose apparent freedoms mask deeper repressions and restrictions.

1 Kynaston McShine, *Information*, exh. cat., Museum of Modern Art, New York, 1970, p.139.
2 Ibid., p.138.
3 Gianni Vattimo, *The End of Modernity*, Cambridge 1988.
4 Fredric Jameson, *Postmodernism, or the Cultural Logic of Late Capitalism*, London and New York 1991.
5 Ibid.
6 Karl Marx, *Grundrisse*, Pelican Books edition, London 1973.
7 Maurizio Lazzarato in Paola Virno and Michael Hardt (eds.), *Radical Thought in Italy: A Potential Politics*, Minneapolis 1996.
8 Theodor Adorno, *Aesthetic Theory*, London 1984.

VIEWERS WANTED
RALPH RUGOFF

Do art exhibitions regularly leave you feeling tired, listless, or uninspired? Have you ever felt as if the work on display had no interest in engaging your intelligence or even acknowledging your presence? Do you often feel lonelier and less connected after such encounters?'

If you have endured any of these unpleasant symptoms, don't despair. Your experiences are shared by many others. But there is an alternative. For more information call 0800 …'

If you could peruse the classified advertisements section of my mind, you would find this announcement under the heading 'Viewers Wanted'. If a complete phone number were listed, I would have called it myself numerous times, as I have visited more than one exhibition that left me feeling unwanted and out of the loop, like an irrelevant outsider who simply didn't 'get it', no doubt due to some glaring deficiency of my own.

At other times, I have slouched out of a gallery wondering if the exhibition organisers had aspired to the ideal, formulated by the critic Michael Fried in the 1960s, that truly great art must be self-contained, to the point where it maintains the 'supreme fiction' that the viewer simply isn't there.

Many of the exhibitions in question were large group shows — biennials or triennials — which tried to breath fresh air into museums by showcasing the triumphs of the moment. Given a novel theme and provocative title, or simply a reasonably exhaustive list of familiar names and an adequate publicity campaign, biennials and triennials predictably catch the attention of the press and frequently become landmarks of cultural tourism. But beyond their packaging as novelties, I usually couldn't discern any meaningful threads linking the various art works or their presentation. Whether national or international in scope, such exhibitions were generally more concerned with the places artists come from than with the experience of place created by bringing their work together.

As a result, they evince an impersonal and somewhat arbitrary character, often leaving an impression that the curators might just as well have picked the artists at random and presented their contributions in alphabetical order (a procedure followed, in an ironic gesture, for a group show guest-curated by the artist Christian Boltanski at the Pompidou Centre in 2000). So even when these exhibitions feature some very good art, as many of them do, their packaging inevitably blunts our experience of it. And although we may not always we aware of it, most of us are profoundly susceptible to the way an experience is packaged. This tendency, which forms the cornerstone of the consumer research industry, most certainly comes into play when we look at art.

But is there really an alternative? Is it possible to package and present contemporary art in another manner: one which engages our intelligence and which, rather than talking

down to us, invites us to converse and debate? And to what extent is the museum itself a problematic container or package for contemporary exhibitions? Indeed, subdued by the anonymity of institutional order and decorum, even the most playful and idiosyncratic works of art can end up appearing ponderous and stale, embalmed in the self-important aura of 'high' culture.

Undoubtedly there are people who enjoy the museum's atmosphere of infallible authority. It's very reassuring, after all, to be in a place where we never have a moment's hesitation as to where we should look, and where not to. But the problem is that the museum's overly explicit mode of display can also put us to sleep. It attracts our attention only to immobilise our curiosity. It does so by presenting art in such a way that we seem to dominate and control our inspection of it, giving us an illusory sense of its total availability and transparency. In this way we are directed only to look at works, rather than encouraged to question the type of look they solicit.

This style of presentation insinuates that the exciting work of discovery has already been carried out, and that all that is needed from us is an ability to point our eyes in the indicated direction. Thus while much contemporary art aims to disrupt our certainties, museum exhibitions frequently short-circuit that capacity. They allow us little chance of being caught off guard or taken by surprise. Yet, oddly enough, if you polled the directors and curators of our leading institutions, they would almost unanimously agree that exhibitions should do the opposite — that they should facilitate our experience of discovery before works of art, and encourage us to entertain unexpected thoughts and insights.

The difficulty is: how do you encourage an experience of 'discovery'? Since we cannot discover anything with which we are already familiar, the first step must necessarily involve creating a sense of distance between the audience and the works in an exhibition. If we are always sure of how to approach the art on display, we miss out on the opportunity to ask questions, to digress, and to discover where our own thoughts and feelings lead us. For this reason, one of the most valuable things an exhibition can do is encourage us to entertain a degree of uncertainty not only about the nature of what we are looking at, but about what criteria we 'should' be using to judge it — and perhaps

to wonder as well if judgment is really our most intelligent or interesting response.

In an attempt to encourage this kind of response, numerous curators over the past two decades have fled the museum and its neutralising effects, and have instead organised contemporary art shows in unexpected venues. From warehouses to airplanes and boutiques, from the Freud Museum to the Liberace Museum, they have held exhibitions in places where we don't expect to find works of art, in the hope that our experience of the work might itself take on an unexpected quality, presumably allowing us to look at things with fresh eyes.

The museum, however, is not so easily left behind: ultimately it is not only a physical milieu, but also a way of seeing things, of relating to objects and spaces as if they were quarantined within an airtight vitrine, or hemmed in by invisible quotation marks. This mode of perception, whose history can be traced back not only to the evolution of the museum but to other nineteenth-century developments such as the department store window display, has become pervasive today thanks to our habits of peering through camera viewfinders and car windshields, of watching life unfold on television screens and computer monitors. To our detached and distanced eyes, the whole world has become a virtual exhibition situated somewhere on the other side of an endless screen.

Naturally, we bring this passive mode of viewing, which is basically a kind of mental window shopping, to the art shows we visit. To encourage us to become more active viewers, then, exhibitions need to first distance us from our already-distanced gaze. This involves detaching us from the idea of being mere 'spectators', non-participants who have no critical role to play. To achieve this, exhibitions must somehow convey a sense that they include space for our own contributions, that they don't simply present culture, but are involved in the process of inventing it in a deal worked out with each and every visitor. Instead of handing us a *fait accompli*, they can ask us to join a negotiation that is still in process. They could aim to remind us, as Duchamp insisted, that the viewer is responsible for half the work in art's creation.

This entails extending an invitation to explore an exhibition, rather than simply witnessing it as if from the perspective of a conveyor belt smoothly moving from point A to point B. While an invitation of this kind

may also pertain to the way we physically navigate the space of galleries, it is above all concerned with the experiential and conceptual terrain we encounter in our journey from one art work to the next. To ensure our acceptance, this invitation must also be generously phrased, taking into account the full complexity of our relationships with objects, which call into play our visceral reactions as well as our desires and a vast array of psychological responses. As the painter Patrick Collins said, our encounter with art takes us 'from the eye to the stomach to the head'.

An exhibition can engage the full spectrum of our intelligence only if accommodates each stage in this process. It also needs to allow for the composite motives that distinguish our exhibition-going experiences, in which the voyeuristic dovetails with the apparently profound. Only in this way will an exhibition be able to speak to us as the contradictory individuals that we are, and not simply as generic members of the public, a fictional role in which no one ever feels completely at home.

By contrast, too many large-scale contemporary shows address us in ways that close down the intricacy of our encounter with art, appealing to us secular pilgrims, art tourists, or as postmodern consumers hungry for sensation-arousing events. And sometimes, of course, the nature of the appeal is so vague that we may leave an exhibition unsure why we came in the first place, whether it was simply out of obedience to convention, a sense of obligation, or a desire for offbeat entertainment.

Imagine how differently it would feel to be addressed as a partner and collaborator. This may sound absurdly idealistic, but it is not impossible. Exhibitions and works of art can achieve this by giving us a sense that they incorporate our responses in one way or another. Rather than merely ask us to put together the pieces of a jigsaw puzzle, they can prompt us to reflect on the choices and motives embodied in the form and shape of each piece, and enjoin us to assemble our own version of a show from the raw materials we encounter during our visit. And perhaps most importantly, they can make us feel that our questions are worth holding on to as aesthetic acts of pleasure, and as an indispensable means of extending our experience of art into other areas of our life.

When we can freely entertain questions

about what we are looking at, we may also be prompted to wonder about ourselves. In this way the small discoveries we make about an exhibition can lead us towards moments of self-discovery. Not in a solipsistic sense, however, as the insights we glean have less to do with that figment called 'me' than with understanding how we actively participate in fashioning and framing our experience of objects and images — and not just those in museums, but in the world at large as well.

A smart exhibition can speak to our public as well as our private selves. Indeed, by its nature exhibition-going is an almost uniquely hybrid composite of public and private, as our intensely personal scrutiny and investigation takes place in a communal setting where, unlike the theatre or concert hall, there is no imposed code of silence or assigned seating. In the museum's open areas, we are free to move about and mingle with strangers, to overhear conversations and respond to the remarks of a companion.

Unfortunately, most exhibitions aim to convince us that this provocative arena is a dead zone — that as we march from object to object, we pass only through empty and meaningless space, and so should hurry along as efficiently as possible. By aspiring to be a 'neutral' frame for its contents, this style of institutional display inhibits the communal nature of our visit, and our potential use of an exhibition as a site for meaningful exchange not only between works of arts and visitors, but between individual visitors as well. All of which forms an essential part of the 'work' of a work of art. When all is said and done, after all, the labour of individual artists is transformed, through its public display, into a cultural endeavour in which we all participate. To fully acknowledge this, exhibitions must do more than invite us to admire works of art in respectful silence. They must dream of becoming places where we come to exchange views, discuss and debate, incited and amused by the spaces and objects we explore. Visitors to such a forum would no longer be 'spectators', but muses to one other, creating out of our private responses to works of art a shared display of wit that, until that moment, had never been publicly realised. And in this lively exhibition of our intelligence, we might realise anew that art lives on only in the uses we make of it.

JULIAN OPIE

MARK LEWIS

DOUGLAS GORDON

SUSAN HILLER

TACITA DEAN

GRAHAM GUSSIN

MARTIN CREED

BOB AND ROBERTA SMITH

LIAM GILLICK

BRIGHID LOWE

RICHARD WRIGHT

ALAN JOHNSTON

HILARY LLOYD

JAKI IRVINE

OLADÉLÉ AJIBOYÉ BAMGBOYÉ

YINKA SHONIBARE

MICHAEL CRAIG-MARTIN

GILLIAN WEARING

SARAH LUCAS

JEREMY DELLER AND ALAN KANE

WILLIAM FURLONG

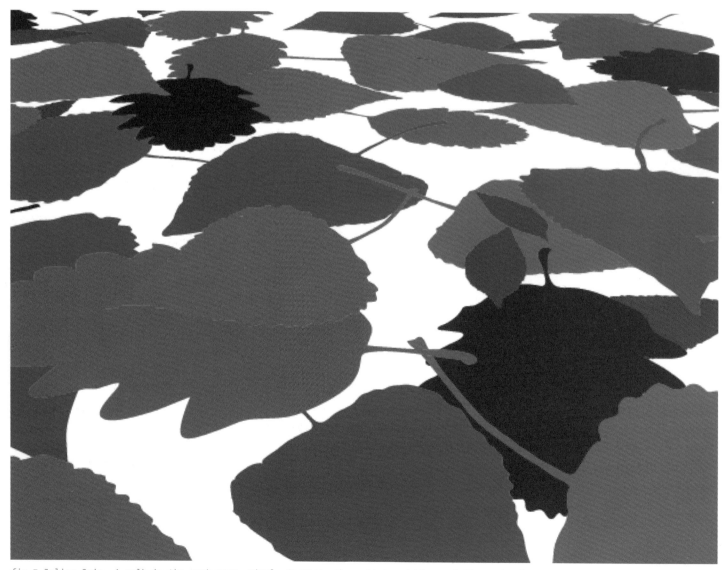

fig.7 Julian Opie, *A walk in the park* 2000, vinyl. Courtesy the artist and Lisson Gallery, London

What I would really like to do is make a painting and then walk into it.[1]

Julian Opie embraces the simulated world, focusing attention on the interchangeability of real and imaginary, actual and virtual. The cool minimalism of his computer-generated sculptural environments imply a utopian optimism. Yet his mute, pared-down symbols of familiar things also suggest banality and repetition. This apparent contradiction stems from an unresolved philosophical dilemma, derived from a conflicting sense of enchantment and disenchantment with the modern world, the world of super highways, cyberspace, information technology, standardisation, genetic modification and cloning.

Computer technology plays a crucial role in the execution of Opie's work, which comprises a series of 'options' stored on computer-like 'files on hold', to be called up if and when required. Opie's methodology provides a practical solution to exhibition making. Component parts — typically cars, buildings, trees, backdrop paintings — can be selected and assembled in response to the specific needs of each space. The artist has said:

I see sculptures as functioning a bit like objects in an IKEA catalogue. They can exist on their own but are also capable of being combined in many different ways with other objects from the catalogue, to create a larger whole; an exhibition in my case or a home in the case of IKEA. Each object stands in relation to the others, but in a flexible way. What I show is not definitive. I want the viewer to imagine that they could re-order the elements or that they would be re-ordered in another venue[2]

Opie's symbols are derived from commonplace objects in the real world. Over the years, he has amassed an extensive and ongoing archive of his own photographs, which frequently provide a starting point. Though distilled from several sources, his generalised symbols retain sufficient detail to be convincing.

As a child might play with building blocks, so Opie experiments with his modular systems, trying out various possibilities and scenarios. He has said:

As children we learn to use and recognise things in the world by using scaled-down equivalents. In this form they become knowable, manipulable, fun. Playing is interacting with the external world through symbols.[3]

When children play, they invariably create narratives, acting out and re-enacting how they would like the world to be. Opie is similarly interested in a sense of narrative space, a narrative suggested by the juxtaposition of particular objects, colours, backgrounds, and more explicitly, a narrative created by the viewer as he or she moves through the installation in the gallery. For him, narrative space, such as that experienced in a computer game, produces a heightened sense of realism:

> In computer games simple graphics create places. A few graves become a graveyard; some castellated walls, a fortress; ten identical trees, a forest. They sit on a flat round and need not be realistic. It is the interactive movement around them and your recognition of a classic type that brings them to life … The world seldom presents itself as a view. When it does we stop and photograph it.[4]

Opie envisages that, moving through the installation, visitors will register their own experiences, creating a series of 'moments'. His desire to engage the audience is most clearly demonstrated by such earlier series as *Imagine you are driving* (1991–3), which literally invites the viewer to take a leap of the imagination into a picture of the open road. In these works, he precisely pinpoints the closing gap between real and virtual experience.

For this exhibition, Opie has grouped large-scale vinyl paintings with several life-sized semi-abstract figures. The paintings correspond to traditional genres of art usually seen in the nineteenth-century rooms of museums and galleries, such as portraiture, still life and the nude. Although they mimic the conventions of high art, these paintings also resemble standardised vernacular images found in magazines, at the airport, in the supermarket, on the street. Interestingly, the way in which the paintings are produced echoes both traditional methods of composition,

and the process by which almost everything is now designed, making any notion of the natural or authentic redundant. For example, the still life vegetables were photographed individually, and the photographs fed into a computer. The artist then modified the images on screen, composing in much the same way as one would arrange a three-dimensional still life on a table in preparation for a painting.

The standing figures are reminiscent of signs found in garage forecourts, shopping malls and the intensely controlled areas of business parks. Though derived from photographs of real people, they belong to the shiny, plastic world represented in his paintings. In the context of the gallery, they might be read as conventional sculptures installed alongside paintings. Opie acknowledges the richness of visual references in our culture and points to their complex interrelationship in the age of mass reproduction, calling into question the value invested in one cultural form over another. More importantly, using scale, colour and composition, his installation is constructed as a spatial experience. Each image, for example, represents a different way of describing space. Leaves are depicted as they might be observed when you look down on the ground, their layers creating a compressed, rather than infinite, sense of space (fig.7). Encountering Opie's gallery at the outset of this exhibition might heighten the viewer's experience of moving through a space, and suggest the possibility of creating an alternative exhibition, in which the viewer is the constantly shifting point of reference.

1 Julian Opie, quoted in *Julian Opie*, British Council exh. cat., 9th Indian Triennale, Lalit Kala Academy, New Dehli 1997, p.52.
2 Ibid., p.17.
3 Ibid., p.54.
4 Ibid., p.46.

fig.8 *Christian, artist* 1999, vinyl. Courtesy the artist and
Lisson Gallery, London

fig.9 *Virginia, housewife* 2000, vinyl. Courtesy the artist
and Lisson Gallery, London

I think artists have probably always felt
a little envious of cinema, its ability to
gather huge crowds of people and immobilise
them, have them transfixed by the image
for up to ninety minutes or more — this is
something that high art can never do …
But perhaps artists recognise that this
immobility that the cinema organises is
also a problem.[1]

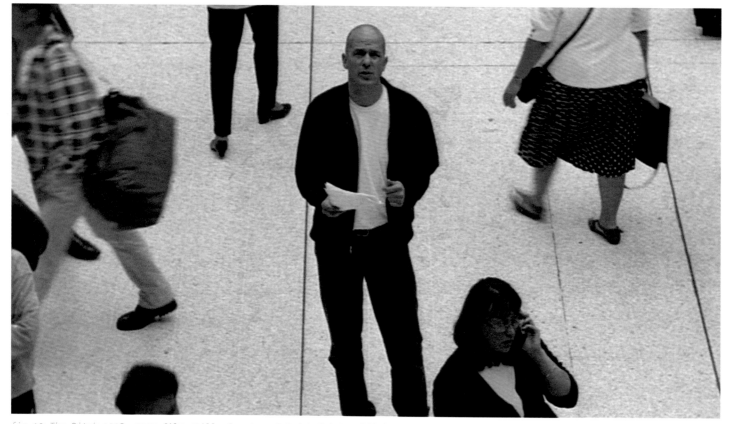

fig.10 *The Pitch* 1998, 35mm film still. Courtesy Patrick Painter Editions, Vancouver

The artist stands in a public place and looks up at the camera to address his unseen audience. With persuasive urgency, he delivers a pitch about his desire to make *Extra, Extra*, a big-budget film devoted exclusively to film extras, usually seen only as the human backdrop against which the central protagonists or stars perform. Lewis argues that extras are integral to the illusion created by cinema, since their presence makes the film seem real. Extras often have specialist skills, perfecting a range of roles required for different genres of film — cowboys, disco-dancers, drunks, corpses. Yet, he concludes, their crucial contribution is overlooked — anonymous and unappreciated, extras are the 'silent proletariat' of the film set.

As Lewis expounds the qualities of the extra, the camera's focus slowly widens to reveal business people, shoppers, tourists, a pregnant woman, people of all types and ages, who move in and out of frame, appearing around him in the apparently spontaneous and natural manner of the extras he describes. The climax of his pitch is a declaration that the film would be in Cinemascope. The gradual zoom of the camera, which matches the exact length of the film — a single 400-foot roll of 35mm stock — reaches completion. At this point, it becomes clear that Lewis is standing in a public concourse, probably a railway station, and that the 'cast' of his film are in fact passers-by. In presenting his pitch, its aspiration has been fulfilled.

Lewis has made a series of films that isolate particular elements of mainstream and avant-garde cinema, which he identifies as cinema's real inventions. By presenting these standard elements — opening credits, the intermission, the trailer and the extra — as stand-alone films, he forces us to re-evaluate such familiar tricks of the trade, to look beyond the cliché. He describes these components as 'the part cinema', and in one sense, they are literally parts of film. Cinema has undoubtedly influenced the

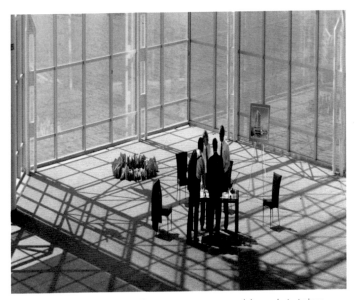

fig.11 *Two Impossible Films* 1995–7, anamorphic print taken from 35mm film. Courtesy Patrick Painter Editions, Vancouver

way we see and understand the world, and its impact on art has been considerable. Most films rely on narrative techniques, dramatic effects, and the controlling environment of the traditional movie-theatre. Lewis's work functions as a critique of Hollywood film, yet — as he freely admits — it cannot exist without it:

> These bits of cinema that I have been making are only possible because of the totalising dream of the traditional dramatic cinema. They can never simply be against that dream as their effects are born of it. The language of my films is the language of both commercial and avant-garde cinema.[2]

In 1999, Lewis wrote a full-length feature film. He then removed the dramatic high points from the script, leaving only the scenes that follow key moments in the plot. What remained from this process of erasure resulted in a sixteen-minute piece, *After (Made for TV)*. Like much of his work, it takes the form of a proposal, presenting the viewer with the possibility of what cinema could be. Like *The Pitch* (1995), it attempts to isolate what is truly innovative from the 'background' of traditional forms. Omitting pivotal events from the

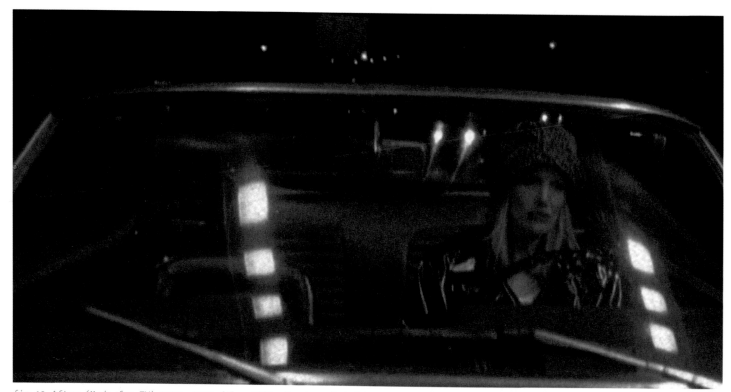

fig.12 *After (Made for TV)* 1999, 35mm film still. Courtesy Patrick Painter Editions, Vancouver

narrative, the film teasingly points up the audience's capacity for imaginative projection and aesthetic judgement.

In the mid-1990s Lewis set up a production company, Impossible Films, in order to make a 35mm, Cinemascope, single-screen projection *Two Impossible Films* (1995–7). In this piece he exploits the cinematic invention of opening credits. Elaborately developed in high-production-value Hollywood films, the opening sequence aims to set the tone and capture the undivided attention of the audience. It often contains the film's most exciting and experimental imagery, severing the viewer decisively from the world outside the movie theatre with a promise of escapist entertainment. Like 'stand-alones', the two opening sequences here can be understood in relation to a greater whole, yet at the same time they are complete in themselves. Watching the sequences can be disappointing because they arouse expectations of what might follow. This points to the grip that traditional cinema has on the imagination, and at the same time makes the audience responsible for imagining the full-length

productions. In celebrating cinema's inventions Lewis seems to revel in the idea of the new, of the avant-garde, whilst at the same time acknowledging the impossiblity of creating new cinematic forms that are independent of the mainstream. The notion of the impossible relates to the potential aspiration of the artist, as Lewis puts it:

> To celebrate the impossible, or to align oneself with it, is to invest in the utopian desire to imagine what might be possible in an ideal world; but it's also, I think, to acknowledge and celebrate everything that utility and logic will not tolerate, even in that ideal world.[3]

The Pitch is self-fulfilling proposition. By implication, the viewer in the gallery assumes the same position as the extra in the crowd sequence — at once inconsequential and central, and potentially decisive.

1 'Mark Lewis in Conversation with Jeff Wall', *Transcript*, vol.3, issue 3, 1999, pp.185, 189.
2 Ibid., p.169.
3 Ibid., p.182.

my reverend father explained to me how he had wrestled with God … for days and years … but that he had prevailed, and … that I was now a justified person, adopted among the number of God's children — my name written in the Lamb's book of life, and that no bypast transgression, nor any future act of my own, or of other men, could be instrumental in altering the decree.[1]

fig.13 *Confessions of a justified sinner* 1996, video projection (2 screens and strobe light). Private Collection

The Scottish writer James Hogg is probably the single most influential figure on the work of his compatriot Douglas Gordon. This short extract from his strange, schizophrenic, *Confessions* of 1824 is taken from the pivotal point in the book's narrative. Robert Wringhim, the narrator of this part of the book, is confirmed into the community of the just through his father's struggles and his name's inscription in the 'Lamb's book'. He is immediately aware that it is now impossible for him ever to fall away from that state of grace. In contemporary terms, the character's psychological motivation is established, explaining

Wringhim's subsequent fearlessness in the face of both god and the devil, and his certainty as he sets out on his murderous exploits.

James Hogg penetrates the Scottish sense of self even more thoroughly than Robert Louis Stevenson's Dr Jekyll and Mr Hyde. For Hogg, the fanatical Calvinism of Wringhim's family becomes a means to talk about the twin meditations of good and evil in a harsh moral climate, just as Stevenson's meditation on the alter ego reflects a deep-seated Scottish ambivalence to faith and (national) identity. Douglas Gordon is heir to this tradition, as an artist whose work pulsates with similar, equivocal energies and is further informed by an understanding of twentieth-century psychoanalysis and its concept of the split or multiple personality.

List of Names is one of Gordon's first works to make use of aspects of this material. First shown in 1990, the piece begins as a struggle in the artist's memory to account for all his friends, acquaintances and the people he has met in passing. The name of each remembered person is inscribed on the wall, testament to their existence and also to their continued relevance in Gordon's life. Each time it is remade,

fig.14 *A Divided Self II* 1996, video still. Private Collection

the task of remembering and recording is begun again, so each list differs from its predecessor through both addition (as time passes) and omission (as people are forgotten). The list is inevitably always incomplete, but in its attempt to be inclusive it is generous to a fault, an attempt perhaps, learnt from Hogg, to save the world or at least that part of it with which Gordon has come into intimate contact.

Conversely, the work at first sight resembles a memorial to the dead, like the many that can be found in the centre of small villages and towns throughout Britain. These lists of individual names still serve as a salutary reminder of the unprecedented loss of life through war during the twentieth century. In Scotland especially, the First World War decimated the male population, and caused such huge social and economic reversals that it continues to have a significant effect on the country's society. Internationally, the work brings to mind Maya Lin's Vietnam Memorial in Washington DC, another list of countless names, each known to someone. However, if *List of Names* is a memorial, it is not to the death of these individuals but to their lives. Rather than marking a supreme moment of sacrifice or the culmination of an existence, these names are recorded because of their owners' professional activities, family ties or simply chance encounters with the artist. It is

this prosaic justification for their inclusion that makes the work personal rather than monumental. These people have circled round Gordon just as they surround the viewer in the gallery. As he has said:

> The influence of artists is only as important as that of teachers, writers, rockers, chefs, footballers, djs, poets, singers, politicians, historians, economists, doctors, nurses, philosophers, deities, psychiatrists, mothers, fathers, sisters, brothers, lovers, ex-lovers, future lovers and so on and not in any particular order.[2]

Accordingly, *List of Names* can be read as an account of the formative influences on the individual who called it into being. In this case it is an artist who has often questioned the origin and significance of the creative act itself. Video works such as *24hr Psycho* (1993) or the *Bootleg* series (1996) play with the idea of authorship and responsibility by making use of existing films to force a concentration on the reception of the image in the mind of the viewer rather than the skill or genius of the creator. For instance, *24hr Psycho* radically changes the conditions of reception by slowing the film down to last a day and a night, while otherwise leaving the material unaltered. The effect on the psychology of the viewer is astounding, as the perception of the whole world, and not just the film, falls into line with this new, ultra-slow speed. The *Bootleg* works also roam about this territory, using bootleg videos of live concerts from The Smiths, The Rolling Stones and The Cramps. The sound is removed, and the image is slowed down and projected onto separate free-floating screens arranged in a single space. As one stands between the screens, the atmosphere in the viewer's head is intense and claustrophobic, not unlike the original gig perhaps. The slow motion and the lack of sound, however, promote more theoretical enquiries into the ecstatic nature of pop

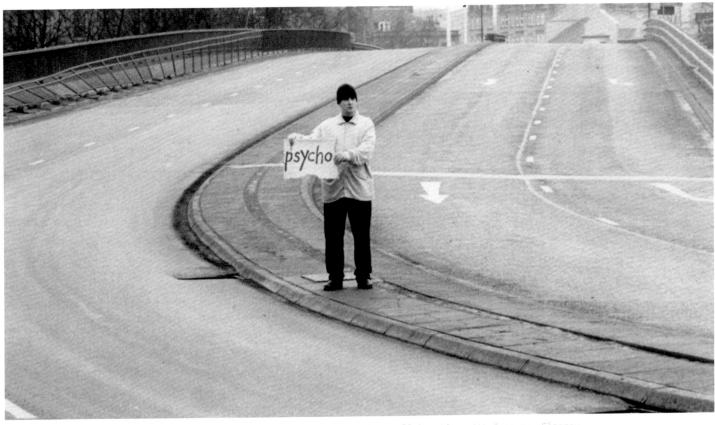

Fig.15 *Psycho Hitchhiker* 1993, black and white photograph. Produced in collaboration with Tramway, Glasgow. Private Collection

ritual, while the hands of the Stones' fans sway uncontrollably in the air, darkly beautiful and vaguely reminiscent of religious mania and Dionysian rites.

These attributes of Gordon's work and its effect on the viewer are equally present in *List of Names*. Less visually seductive, the piece nevertheless triggers the imagination in the same way. Celebrity names crop up, ones that virtually anyone from the West would instantly recognise, but this form of recognition is not particularly helpful. Instead, it is more tempting to make up life stories, connections between names or perhaps imagine the work as the artist's credits — the run-out time at the end of the film when the lights go up, the surroundings reassert themselves, and companions start asking what you thought about the movie.

1 James Hogg, *The Private Memoirs and Confessions of a Justified Sinner*, Edinburgh 1996, p.94.
2 Douglas Gordon, interviewed by Clare Bishop, *Flash Art*, vol.32, no.207, 1999, p.105.

Hiller's art lives where we all do —
between the everyday and the spiritual,
microcosm and macrocosm, ordinary and
extraordinary. Her quest is for a new
language to oppose or expand that of the
dominant culture, a language that will be
generous enough to include the desires of
outsiders. Such a language would also
include material from the 'outer limits',
the unspoken or the out-of-control.[1]

Nothing about Susan Hiller's art can be
assumed. She moves freely between materials
and media — working sometimes with video,
sometimes with paint, sometimes with sound.
Her resources extend to her closest friends
and across the borderless space of the
internet, but always her ideas spiral
around a deeply felt set of principles and
an intense curiosity about the strangeness
of the human adventure. At one level, her
work has been consistently about placing
a value on marginal, 'irrational' experi-
ence. She observes that many demonstrable
events are dismissed as coincidence, misun-
derstanding or even madness and there-
by excluded from public discourse and
'rational' thought. Yet these experiences
stay within us, locked up because they have
no place to go within our common utilitar-
ian worldview, and emerge again through
dreams, children's tales or secrets between
close confidants. As she has said:

Our culture more than most makes a dis-
tinction between the rational and irra-
tional, between empiricism and intuitive
ways of apprehending the world. In my
experience those kind of distinctions
don't have any validity. In my work, I'm
trying to approach a kind of reconcilia-
tion of rational and irrational factors
which seem to me a lived truth for
many people. For myself, I can only
say that this is part of the way I see
things.[2]

This refusal to indulge in what might be
termed dualist thinking is complemented by
a further breaking down of traditional bar-
riers between artist and audience. Hiller
studied anthropology before turning to art
and has a perceptive eye for her own cul-
ture and the negotiations that take place
between personal expression and social
conformity. She uses this experience as a
means to collect material and to develop
the formal language through which her
seductive installations communicate. It
is important to remember that, although
physically transformed, each work remains
a collaboration both with her sources and
audiences. Here, as with much of the work
in *Intelligence*, meaning is directly located
in an exchange between artwork and viewer.
Hiller's work reveals images and ideas that
are already present in the culture, though
perhaps unrecognised and awaiting visual
or contextual translation. For instance, in
Belshazzar's Feast (1983–4), Hiller's video
programme first broadcast on Channel 4 at

fig.16 *Wild Talents* 1997, video laser-disk with chairs and lights. Installation at Foksal Gallery, Warsaw, 1997

the end of a night's transmission, many viewers believe they can discern strange faces, figures or landscapes in the simple imagery of a domestic fire. The work was based on newspaper stories of people seeing 'ghosts' in their television after the channel's shutdown. The artist treated the fire imagery with various effects such as double exposure and the soundtrack includes a whispering voice, crackling logs and mysterious wordless singing, creating an effect close to a shared hallucination.

An equally thought-provoking and consistent trace in Hiller's work has been a series of investigations into the wide range of phenomena usually grouped under the term 'paranormal' and including automatic writing, telekinesis and telepathy. They have a particular historic relationship to art, from the figure of the shaman to surrealist experiments with automatism and critical

responses to abstract expressionism. This lineage is drawn upon in Hiller's works, just as she explores popular cinema's fascination with the occult, or Sigmund Freud's collection of minature gods and devils, to make evocative drawings and installations. In works as different as the automatic scripts of *Sisters of Menon* (1979) or *From India to the Planet Mars* (1998); the compelling video installations *Psi Girls* (1998) or *Wild Talents* (1997) and early pieces such as *Dream Mapping* (1974), the artist preserves the wonder of these events against the equally irrational view of the undiluted cynic. In doing so, she always avoids taking sides but simply deals with the evidence as 'social facts' that might reveal something of ourselves and our hidden possibilities.

Hiller's latest work is called *Witness*, (2000) and is featured in *Intelligence*.

fig.17 *From India to the Planet Mars* 1998, photographic negatives, lightboxes.
Installation at Institute of Contemporary Art, Philadelphia, 1998

The piece is typical in that it continues her investigative theme while creating a strong and distinctive visual form. The artist has gathered hundreds of accounts of encounters with UFOs or aliens that were posted on various internet sites worldwide. She sees this activity as related to older forms of confession or bearing witness, ways of placing fears or doubts into the public arena. Her working process becomes a new kind of exploration of contemporary folklore, one in which alien contact is offered as an explanation for the inexplicable. Perhaps such visions can be likened to the manifestations of gods, giants or angels that once represented a similar uncontrollable agency. In *Witness*, hundreds of tiny speakers, suspended from a cruciform shape evoking the religious symbolism of classic ufology, murmur these stories in all their original languages. The work provides several distinct audio experiences, depending on whether the viewer stays on the periphery or moves slowly towards the centre, isolates one voice at a time or listens to the cacophony of the whole assembly.

It is the magic of the work that it draws on the immediate power of storytelling and the accounts of a range of people, whilst hinting at much broader social and spiritual gaps in contemporary society. In doing so, it creates a picture of the way our perceived realities are culturally generated, created by the actions and imaginations of human beings.

1 Lucy Lippard, in Barbara Einzig (ed.), *Thinking about Art, Conversations with Susan Hiller*, Manchester 1996, p.xii.
2 Susan Hiller, 'Dedicated to the Unknown Artists: An Interview with Rozsika Parker', in Einzig 1996, p.29.

figs.18, 19 *Bubble House* 1999, 16mm film stills.
Courtesy the artist and Frith Street Gallery, London

On the shoreline, a fantastical, oval-shaped structure, gutted and abandoned to the elements, is filmed in a tropical storm. Wind, rain, encroaching waves and the cries of alarmed birds provide a fitting soundtrack to the artist's considered investigation of this remote and dysfunctional 'bubble house'. The film is built round a series of evocative and lingering shots of the house and its surroundings. Incongruous in its tropical environment, the house looks initially like the wreck of an alien spaceship. Inside the building, bits of its internal structure flail and bang forlornly in the wind. Dripping water forms a wet, reflective film over the floor. The sea, rolling relentlessly towards the shore, is viewed at an angle through one of the cavernous windows. Against the velvet blackness of the interior spaces, this shot of the sea looks like a film of a Cinemascope screen. For a moment, as in many of her works, Dean hints at her fascination with the process of filmmaking itself. At the same time, the viewer is confronted by a framed image, which recurs in her work as a symbol of psychological and physical isolation.

Dean's work seeks connections — between history and the present, fact and fiction.

Her starting point is typically a chance encounter or discovery. She pursues her investigation like a detective, piecing together evidence, which is then presented in a loosely woven, inconclusive narrative. Dean found the bubble house while visiting Cayman Brac in the Caribbean to film Donald Crowhurst's wrecked trimaran *Teignmouth Electron*. This trip and subsequent book (*Teignmouth Electron*, 1999, both commissioned by the National Maritime Museum, London) represent the culmination of a four-year personal research into — and

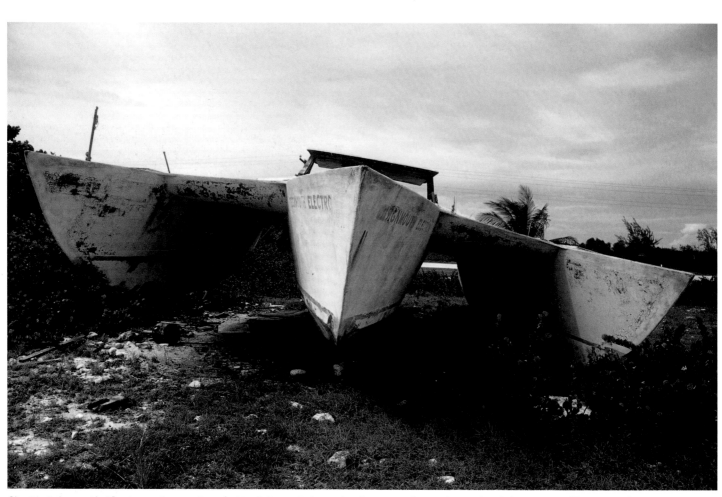

fig.20 *Teignmouth Electron, Caymen Brac* 1999, R-type photograph. Courtesy the artist and Frith Street Gallery, London

involvement with – Crowhurst's tragic voyage.* The amateur yachtsman died in 1969 while participating in the first solo, non-stop, round-the-world yacht race. Realising that he could not complete the race, Crowhurst began concealing his real position. His anxiety about this huge deceit began to distort his sense of reality, and his trimaran was found abandoned, drifting in the Atlantic.

For Dean, there are strange connections between the 'bubble house' and the *Teignmouth Electron*. While on the island, her progress was hindered by a spate of tropical storms. The weather, together with the stultifying affluence of this tax-haven paradise, made Dean claustrophobic. So on the third day of her trip, she and her companion drove along the 'hurricane coast', where the boat lay rotting, and on the road they came across the only other sign of neglect on the island. As Dean recalls:

Deserted and half-complete, the bubble house stood like a futuristic vision: like a statement from another age. We thought it was a temple belonging to a sect, or a church constructed by the Mafia, with the faint imprint of a cross above the entrance. We knew we had come across something otherwordly: the perfect companion to the *Teignmouth Electron*.[1]

Curious, the artist began to make inquiries:

We frustrated our host by asking him about the boat and the bubble house … in his opinion both shameful relics of fraud and deceit. 'Bubble house' was the name locals gave the house, and it appears to have been built by a Frenchman. It was a vision for perfect hurricane housing, egg-shaped and resistant to the wind, extravagant and daring, with its cinemascope-proportioned windows that

looked out onto the sea. Only he was arrested before it was completed; his assets were frozen and he was sentenced to thirty-five years in Tampa prison for embezzling money from the United States government.[2]

Both the boat and the house point to the frailty of human endeavour against the forces of nature — in particular, the sea — and as the artist concludes 'both men involved in their construction paid dearly for their fraud'. In Dean's work, attempts to order, rationalise and control the environment, and, by inference, to control human destiny, are often set against images of nature, which conjure up notions of the untamed powers of the imagination and the unknown. A number of works dwell on mankind's efforts to 'master' the elements. For example, *Delft Hydraulics* of 1997, shot in a marine laboratory in Holland, captures the undulating, rhythmic movement of water in a wave machine. The film is a kind of meditation on attempts to harness the sea, and to reclaim the land it has conquered.

Dean seems drawn to anachronisms. Even the medium she chooses, 16mm film, appears outdated or even nostalgic in today's digital culture. Earlier works, such as *The Martyrdom of St Agatha* of 1994, explore in quasi-documentary style the residual power and contemporary meanings of folklore and relics. Such recent films as *Bubble House* (1999) are less deliberately narrative, lingering on the baffling relics of failed vision or aspiration.

In a subsequent work, *Sound Mirrors*, also of 1999, the artist films giant concrete structures along the Kent coast. Long since defunct and deserted, these decaying, weirdly futuristic installations formed part of extensive experiments into air defence during the 1920s and 1930s. Known as the Hythe Sound Mirror System, they were part of a plan to develop a chain of listening stations along the South-East coast. By 1936, probably owing to the development of radar (then still under wraps), the Air

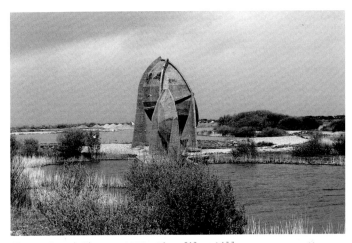

fig.21 *Sound Mirrors* 1999, 16mm film still. Courtesy the artist and Frith Street Gallery, London

Ministry lost interest in the mirrors as an effective early-warning system against aerial attack. To the uninformed eye, the vandalised structures might look like ancient sites, or perhaps discarded props from a 1930s science-fiction film. They were in fact conceived and constructed at a time when western Europe was convinced of the dreadful invincibility of air power.

Dean has commented that even before finding Crowhurst's stranded trimaran she had 'imagined it in the writings of J.G. Ballard', who for her

summons up a time when our everyday will be out of context; when our descendants will read votive meaning into our sports stadiums and race courses; when nothing will be understood by the totems of today.[3]

* Since the time of writing, Dean has completed a film of the wrecked *Teignmouth Electron*, which concludes her investigation of Crowhurst's story.
1 Tacita Dean, press release, Frith Street Gallery, London, April 1999.
2 Ibid.
3 Tacita Dean, *Teignmouth Electron*, London 1999, p.24.

One's mind and the earth are in a constant
state of erosion, mental rivers wear away
abstract banks, brain waves undermine
cliffs of thought, ideas decompose into
stones of unknowing and conceptual crys-
tallisations break apart into deposits of
gritty reason. Vast moving faculties occur
in this geological miasma, and they move in
the most physical way. This movement seems
motionless, yet it crushes the landscape of
logic under glacial reveries … A bleached
and fractured world surrounds the artist.[1]

fig.22 *Studio (Dry Ice)* 1997, black and white photograph.
Artist's Collection

Eerily silent black-and-white establishing
shots take the viewer to different spaces
in a building of uncertain status. Partially
derelict, perhaps recently functional, this
building seems to be both somewhere and
nowhere. The vacuum stillness of the spaces
arouses expectation. Gently, an indetermi-
nate fog begins to creep tentatively into
the spaces, gradually billowing and
enveloping, undulating down stairs, cover-
ing the floor in a living carpet. Like an

alien intelligence, it seems to sense the
environment as it makes its way across
surfaces, consuming everything in its wake.
Then, as stealthily as it has appeared,
the substance quietly recedes. The spaces
look the same, but there is a sense that a
transformation has taken place.

Gussin has worked in a variety of media,
including drawing, painting, sculpture,
video and sound installation. For *Spill*
(1999), his first 16mm film, the artist
released a quantity of dry ice into a
disused building, documenting its advance
and retreat through the space. *Spill*
belongs to Gussin's recent series of inves-
tigations into the production of effects
within the work of art, which began in 1997
with the photograph *Studio (Dry Ice)*. Here,
the artist is portrayed at night in his
studio, which is bleached with the white
light of fluorescent strips. A prominent
spot-lamp enhances the sense of staged
artificiality. By his side is a pristine
white plinth, anticipating the birth of an
art work. But the artist appears immo-
bilised, as if frozen in the sea of dry ice
that cloaks the floor of the studio.

In a subsequent installation of 1998,
Gussin moved the location of production
from the studio to a public space. *Any*

Fig.23 *Spill* 1999, 16mm black and white film still. Artist's Collection

Object in the Universe, made for the Tate Gallery's Art Now room, cast the visitor as producer of the effect, transforming the spectator into creator. The room was partially clad with what appeared to be sound-proofing material. A video projection of a microphone filled one wall. Coming into the room, the viewer walked onto a raised floor, each step setting off an electronically generated echo. Confusingly, the reverberation seemed to come from the projected image, inducing in the viewer a momentary sensation of being trapped (like the echo) between a real and an imaginary space. Later the same year, Gussin made a series of short video works, *Infalling Material*, which show him in a neutral space, this time moving in and out of view to activate or initiate an effect. For example, he walks into the space to put on a tape. As he leaves, the sound of wind fills his empty, white studio, conjuring up a desolate frozen wasteland.

Gussin's interest in the Romantic land-scape tradition informs the way in which he sets out to engage with an audience — like the Romantic landscape, his work seeks the viewer's imagination for its completion. But he frequently creates a prolonged and unfulfilled sense of anticipation. Nineteenth-century Romantic painters such as Caspar David Friedrich (1774–1840) used fog, a natural 'effect', as a powerful evocation of mystery and transformation. A quasi-religious symbolism often attached to it, as an inchoate substance from which the creative spirit — the prime mover — gave form to the world. Jeremy Millar has observed that

in such a context, the emerging landscape within a painting such as Friedrich's *Wanderer above a Sea of Fog* (c.1818) becomes part of the primal scene of creation, the analogy between the production of God and that of the artist inescapable. But such a context is not our own.[2]

figs.24, 25 *Spill* 1999, 16mm black and white film.
Installation at Aarhus Kunstmuseum, 1999. Artist's Collection

As the dry ice in *Spill* gains momentum, it is seen close up, rippling in folds like the waves of some primordial or extraterrestrial ocean. Science fiction has often provided conceptual and visual primers for Gussin's work. Here, the gaseous spillage recalls the mysterious and malevolent liquid surface of the planet Solaris, in Andrei Tarkovsky's 1971 film of the same name. Affected by the peculiar and unexplained properties of Solaris, a group of stationed cosmonauts begin to experience altered states of mind in which their fantasies and fears become reality, with dire consequences. Gussin is drawn to the idea of an imaginary space where fantasy and reality coalesce. Projected on a suspended screen, *Spill* visualises a place in the imagination that seems haunted by the spectre of immolation or suffocation, recalling perhaps Piranesi's phantasmagoric prisons or even the mansion in Edgar Allan Poe's *The Fall of the House of Usher* (1839), which is inextricably linked to the fate of its occupant, Roderick Usher, eventually collapsing to become his tomb. The title of the work is reminiscent of environmental catastrophes such as the fatal poisoning of several thousand people by the accidental release of a cloud of gas from a chemicals plant at Bhopal in India in 1984.

The effluvial quality of the dry ice in *Spill* bears some relationship to American artist Robert Smithson's 'flow' works, namely his *Asphalt Rundown* and *Glue Pour* pieces of the late 1960s and early 1970s. For his first 'Rundown', Smithson released a truckload of asphalt down the hillside of a disused gravel and dirt quarry in Rome. As it set, the asphalt cast the effects of erosion on the hillside, so that the piece became a monument to entropy. But the ephemeral dry ice is closer to the soluble glue poured by Smithson in a similar fashion, which dissolved when it rained, leaving little trace of the artist's intervention. In one sense, the dry ice in the studio represents the stuff out of which an artist might make work. But in his photograph, Gussin appears uneasy. His vaporous material is there but not there, everything and nothing.

1 Robert Smithson, 'A Sedimentation of the Mind: Earth Projects', *Artforum*, Sept. 1968, reprinted in *The Writings of Robert Smithson*, ed. Nancy Holt, New York, 1979, p.82.
2 Jeremy Millar, 'Spill', *Graham Gussin 20 November 1999–23 January 2000*, exhibition information posted on the website of the Aarhuus Kunstmuseum, 1999 (www.aarhuskunstmuseum.dk).

I want to make things. I want to try to make things. I'm not sure why I want to make things, but I think it's got something to do with other people. I think I want to try to communicate with other people, because I want to say 'hello', because I want to express myself, and because I want to be loved. I know I want to make things, but other than that I don't know. I mean I don't know what to make, how to make it, or what to make it from. I find it difficult to say something is more important than anything else. I find it difficult to chose, or to judge, or to decide. I'm scared.[1]

Martin Creed's work takes the form of a series of pragmatic and often humorous solutions to a fundamental conundrum: how to assert oneself in the world, when nothing is certain and little can be relied upon. Much of his work seems born of a self-imposed, almost mathematical logic and can be seen as an attempt to establish some sort of order or rationale, to short-circuit the visually overloaded, choice-saturated culture in which we live. Artists, particularly in the twentieth century, have been expected to have something to say, to deliver moral, spiritual and perceptual insights, to be in the vanguard. Creed's self-effacing approach, which draws to some extent on the strategies of Minimalism and Fluxus, resists any such heroic notion of artistic endeavour. His aim is simultaneously to produce both something and nothing:

I find it a lot easier if it (the work) negates itself at the same time as pushing itself forward. Given that I don't feel sure about it, I feel a lot more comfortable if I can make it and sort of unmake it at the same time.[2]

Creed's position is best expressed by *Work No.143* of 1996, an equation broadcast from March to September 2000 in neon from the frieze of Tate Britain's facade:

the whole world + the work
= the whole world.

Reading like a mission statement or artist's manifesto, this dictum suggests that the work of art, and Creed's work in particular, has no impact whatsoever on the world. A more positive interpretation would be that art is not a rarified sphere of activity, but inextricably part of life. Creed's works are all consciously made of the most mundane and modest of materials. *Work No.88* for example, consists of 'a sheet of A4 paper crumpled into a ball', while *Work No.74* (shown in *Intelligence*) comprises a 2.5cm cubic stack of masking tape. For Creed, the most perfect material is air — immaterial, everywhere and nowhere. *Work No.200: half the air in a given space* of 1998 comprises a room containing balloons, which occupy half the space and contain half the air in the room. The artist's instructions explain:

fig.26 owada (Martin Creed, right: guitar, vocals. Adam McEwen: drums. Keiko Owada: bass, vocals)

Choose a space. Calculate the volume of the space. Using air, blow up white, 12-inch balloons until they occupy half the volume of the space. As usual the space should be full of air, but half of it should be inside balloons. Extra balloons may be added over time to maintain the volume of the work, or else the balloons may be left to deflate naturally.[3]

Creed tends to make his work in response to the actual conditions with which he is presented, the givens of any particular environment. Seemingly slight in scale and ambition, many of his works nevertheless have the paradoxical effect of interfering with and drawing attention to these givens, exposing rules or limitations that are usually taken for granted. *Work No.129: a door opening and closing* comprises a mechanism attached to an existing door that is timed to open and close at regular intervals. In the context of a gallery, such a door might be the entrance to a cupboard

fig.27 *Work No.101: for pianoforte* 1994, ink on paper. Courtesy the artist and Cabinet, London

or lead to spaces behind the scenes, allowing the visitor a glimpse into areas usually out of bounds. *Work No.127: the lights going on and off* of 1995, directly alters the visitor's experience of a space as the lighting system is momentarily shut down and seconds later restored. Creed tampers with existing systems, subtly undermining the authority of the gallery and questioning its certainties.

These pieces can also have a disturbing, lingering effect. A door opening and closing, half-observed from the corner of the eye, is a slightly unnerving experience — did someone enter the room, or suddenly disappear? Why did the lights go out? Is the reliably controlled environment falling apart? This sense of disquiet is created by a recent neon piece, *Work No.220: DON'T WORRY* (2000), exhibited in *Intelligence*. The calming influence of this oft-repeated phrase is undermined by the fact that every other second the neon lights go off. Such words of reassurance are often used when we feel most anxious. Seen in the context of the gallery, they suggest the kind of utopian role that artists might wish for, while puncturing any such ambition.

One of Creed's key raw materials is music. In 1994, he formed the band owada, for which he writes the music and plays guitar, accompanied by Adam McEwen on drums and Keiko Owada on bass. When composing

fig.28 *Work No.201: half the air in a given space* 1998, multi-coloured 11-inch balloons, number of balloons variable. Collection Jack and Nell Wendler, London. Installation at Gavin Brown's enterprise Corp, New York, 1998

music, vexed by the same dilemmas and doubts, Creed falls back on the most reliable of fundamentals in a way that pushes towards absurdity. The band's first album, *nothing* (1997), includes tracks such as '30 seconds with the lights off', which is 30 seconds long and should be played in the dark. A recent solo album, *I Can't Move*, contains tracks such as 'S.O.N.G.', in which Creed literally spells out the rigid formula underlying every pop song, namely, introduction, first verse, chorus, second verse, chorus, and so on.

The influence of music, with its system of notes, signs and symbols, is felt in all of Creed's work. The descriptive 'certificates' that accompany each piece function like sheet music, with instructions that can be slavishly obeyed or subjected to wildly individual interpretation. Creed goes to great lengths to avoid choices that might signify some sort of positive preference or indicate a particular world view. For example, the lights are off for as long as they are on, and the door is open for as long as it is closed. This middle ground is perfectly expressed in *Work No.101: for*

pianoforte of 1994, which comprises a musical score of a single note – middle C – the dead centre of the keyboard.

Ironically, Creed's desire not to posit a world view has produced a body of work that points to the range of possibilities and choices available to us, as Godfrey Worsdale has recently observed:

Life is defined by the systematic and the random; by moments of action and inaction and by opportunities and obstructions. We negotiate our path through these variables with a series of reactions: hesitations and interventions, responses which are, more often than not, prescribed by convention. Martin Creed reacquaints us with the intricate nature of this existence.[4]

1 Martin Creed, May 2000.
2 Ibid.
3 *Martin Creed*, exh. cat., Southampton City Art Gallery, 2000, p.69.
4 Godfrey Worsdale, 'Something and Nothing' in *Martin Creed*, exh. cat., Southampton City Art Gallery, 2000, p.49.

I want to communicate the idea that people can make their own art, that they do not have to have me to do it. I think that art is changing and the business of viewing it is changing. The idea of an artist as an individual with something to say is probably a compelling and understandable one, but it is not one that I fit into, because I want the business of art, the participation in viewing of it to be one and the same.[1]

Bob and Roberta Smith are the invention of artist Patrick Brill. He began using pseudonyms in the late 1980s and early 1990s when he was in New York on a Harkness Fellowship, having already been awarded the Prix de Rome for his paintings. In New York, he became critical of the overt commercialism of the art world, and particularly its dependency on the idea of celebrity. As a reaction to the star system that seemed to determine artistic success or failure, he made up five artists, all producing different types of art, and sent slides of their putative work to New York galleries. As one of these artists, Bob Smith, he worked with the performance group Epoch in Brooklyn, inventing Lucky Bags — plastic bags containing a kit for making your own art work, such as a plastic gun and a piece of straw to make an Anslem Kiefer, or a self-assembly Van Gogh comprising a cardboard chair and some orange paint with Artex texture. Brill eventually settled on and developed this amateurish, failed artist character, the antithesis of the successful, 'career' artist.

His recent work in the guise of Bob and Roberta Smith is motivated by a more positive belief in art as a force for change in the world through the creative potential of

fig.29 *STOP IT WRITE NOW! 1999*. Installation at National Museum of Contemporary Art, Oslo, commissioned by Beaconsfield for *British Links* 1999

each individual. Brill has commented on how the dual persona of Bob and Roberta Smith became integral to his aims as an artist:

I suddenly realised that the kind of art I was making was more of an establishment thing and not to do with me … Bob came out of wanting to mark this sort of change: of ceasing to be 'Patrick Brill, British School Painter' and, instead, becoming Bob, who was this generic person who could be anybody. Originally, I was just Bob, but then I started to work with my sister, who really is called Roberta. She … doesn't make art any more, but I

fig.30 *Some different kind of Artists* 1999, vinyl silk and gloss on panel. Courtesy Anthony Wilkinson Gallery, London

fig.31 *Peas Are The New Beans* 1999, vinyl silk and gloss on panel. Government Art Collection

remained as two people: being both male and female keeps all the possibilities open. The idea of Bob and Roberta Smith is that they are fictional, a kind of cipher through which anybody can do anything that they want to do, rather as there are different actors playing Dr Who or James Bond, and with each enactment things are both different and the same. Performance still seems to be at the centre of the work, but the audiences tend to perform as much as you do.[2]

Punk rock was a formative experience for Brill: 'Punk changed my life. It said you have got ideas, energy, but no technical expertise, go ahead make music. This is so liberating.'[3] His work encourages people to become makers of their own culture rather than passive consumers of a culture designed by others. Adopting a distinctly DIY approach, and with a disregard for conventional aesthetic values, many of his installations are interactive, taking the

form of workshops that invite various degrees of audience participation. Crucially for Brill, art presents a forum for conversation and debate, a space where a parallel world can be created, an alternative culture articulated. For him, a gallery can become an agency to promote change, with the potential to become whatever the public wants it to be.

His workshops have involved the public in making bizarre objects such as painted cement vegetables, concrete boats, guitars, and rubber aeroplanes. The projects usually evolve in relation to their location so that they resonate in some way with the anticipated audience. For example, for a project at the Künstlerhaus, Bremen, the artist featured Dick Scum, a local punk-rock musician, in a poster campaign inviting people to a sand-casting workshop in the gallery. *I Need Ideas Please Help Me*, held in Tokyo in 1997, relied on local people to produce objects. Brill has commented:

In Japan, we gave people glue guns and some basic materials and tools and asked them to invent new things. There were

fig.32 Japanese Bob and Roberta Smith and friend *Please Help Me* 1996. Tokyo Big Site, Tokyo. Courtesy the artist

signs in Japanese and English saying things such as 'Invent something new' or Please help me — I need ideas'. They came up with some really beautiful, creative things just made out of junk and then 'wrote in Japanese what they had invented on a piece of board. So it was a conversation between that material, myself, and whoever came along to the show.[4]

Brill's installations usually include signs inscribed with texts or slogans. These have taken various forms, such as a series of fantastic stories in which incongruous characters are thrown together in humorous and puzzling incidents, or a series of authoritative, yet apparently meaningless statements such as 'Peas Are the New Beans' or 'Leeds Is the New Hull'. Full of misspellings, yet carefully painted in household gloss, Brill's often amusing linguistic messages enhance the 'conversational' atmosphere of his installations. Recently,

he has been producing more professional-looking signs, to emphasise the way in which packaging or presentation can confer status on the ludicrous.

For *Intelligence*, Brill has recreated an installation made first at Oslo's Museum of Modern Art in 1999, commissioned by Beaconsfield, London. *STOP IT WRITE NOW!* will invite visitors to the exhibition to post their protests about any subject into a box. On a weekly basis throughout the show, the artist will select a number of these submissions and paint them on the gallery wall. Here, Brill demonstrates his belief in the artist as a facilitator, and in art as a forum for conversation and free speech, a parallel world where ideas can be expressed, and reality can be invented.

1 Louisa Buck, 'UK Artist Q & A: Bob and Roberta Smith', *The Art Newspaper*, vol.10, no.97, 1999, p.65.
2 Ibid.
3 *Bob and Roberta Smith: Improve the Cat*, exh. cat., Galleria Carbone, Turin, 1999, p.10.
4 Buck 1999, p.65.

LIAM GILLICK

If there were conclusions or the end of
a set of thinking [the work] would fail.
There is a provisional quality to things
and that is important for me. I invite
people to be involved in the intellectual
reframing of the idea, I don't present
something and then invite everyone to try
and work out the solution to the visual
puzzle I have left in the gallery.[1]

Liam Gillick is interested in the processes of communication, negotiation and discussion between people and ideas, as well as the bureaucratic systems that govern these relations. He understands all these activities as secondary, though essential, elements in contemporary life, where our abilities to communicate or negotiate determine not only our own status but the potential future of society. This relationship between the micro level of individual discussions and the macro level of social change is at the heart of his work. He is concerned with the connections between the two and whether it is possible to predict how one might affect the other. The structures and texts that he produces are interdependent parts of this activity, but they each have an individual coherence. In its grandest terms, Gillick's project is to rethink possibilities for the future and the alternatives to existing economic and social conditions. Its manifestation, however, is often local, provisional and specific to the conditions he finds at a given site.

In this sense, Gillick's work could be seen as an investigation into history and context, but he spices this with fictional or hypothetical elements, which he calls 'what if? scenarios'. An aspect of this thinking is developed in publications such as *Eramus Is Late* (1995), *Ibuka!* (1995), or *Discussion Island/Big Conference Centre* (1997). These stories generally feature semi-fictional accounts of incidents involving secondary historical figures such as Robert McNamara, John F. Kennedy's Secretary of Defense, or Charles Darwin's brother Erasmus, characters chosen because of their obscured presence in the midst of world-shattering events. They are, in one sense, provisional figures, full of potential but less confined by history than their more famous colleagues. It is in the nature of this provisional quality, as Gillick defines it above, that his imagined situations are fluid and subject to change from straight description to psycho-fiction and even Broadway musical. Similarly, the objects he produces are neither the results of, nor the inspirations for, the narratives, but something in between. They flirt with architecture, design and sculpture while contradicting all three. They appear both functional and useless, both domestic and industrial, their slipperiness as things being part of the drama that keeps us looking and asking questions about their purpose. As one of the characters in the novel *Big Conference Centre* says:

fig.33 *Applied Resignation Platform* 1999, anodised aluminium and Perspex.
Installation at the Frankfurter Kunstverein, Frankfurt 1999. Courtesy the artist and Corvi-Mora

We're not very interested in the central conceptions of future trends. We have nothing to do with discovering the potential of tomorrow or engaging in socio-political pre-archaeology. If central concepts are central concepts, it is often due to compromise and an ability to communicate. Therefore we are interested in people who are not very good at communicating. And that's where secondary analysts come in, because they are often the ones who have the interesting ideas which are difficult to get across effectively.'[2]

The objects he produces are closely related to these narratives, having themselves a kind of secondary status in between the definitions of independent art object and stage prop for a story.

According to Gillick, the role of the artist is also related to this in-between state – working in the spaces separating disciplines, finding possible new relationships and future liaisons. As he says, 'If you are not entirely happy with the way things are, then the options are no longer clear … one option is to try to address the vast central area that includes bureaucracy, compromise, conciliation and so on … to move inside the thinking and add to the confusion'.[3]

The set of possible responses to his work is dependent as much on an awareness of this history, the surrounding context and the time and place in which it shown, as on the intentions of the artist. For *Intelligence*, we asked Gillick to work with

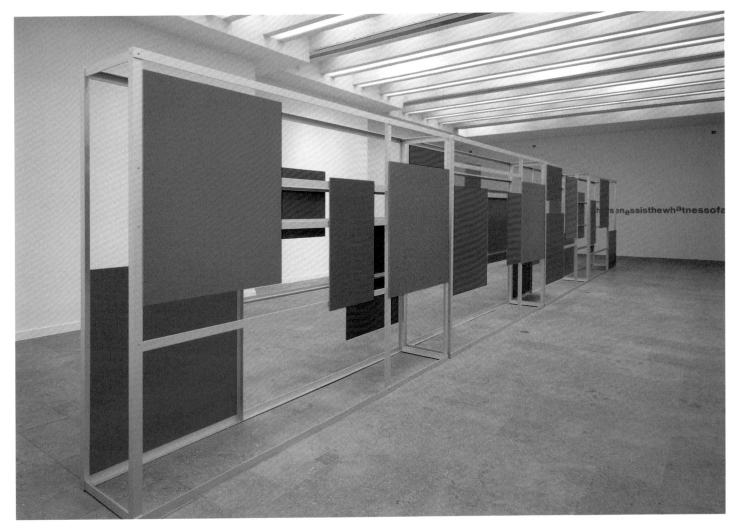

fig.34 *Consultation Filter* 2000, anodised aluminium, plywood and Formica.
Commissioned by the Westfälischer, Kunstverein, Münster. Courtesy the artist and Corvi-Mora

us on the development of the show. His thinking about communication and negotiation is crucial to our understanding of the role of the viewer in art as a subjective investigator. His work for the show is therefore a particular response to the specific needs of this group exhibition. The structure in the centre of the gallery is a kind of architecture from which much of the rest of the show can be observed. The piece both shields and reveals the viewer, allowing time to look out at the show as well as in at Gillick's work. A *Discussion Platform* overhead marks a territory of hypothetical negotiation, while the texts and diagrams on the panels record some parallel thinking provoked by the work of the other artists in the exhibition. The title *Applied Distribution Rig*

defines the position of the work. It is 'applied' in the manner of applied mathematics, given over to the attempt to solve an actual problem in the real world. It is about the redistribution of ideas generated by the exhibition's title and the works on display at a point halfway through the show, when a certain account can be taken by the viewer. Finally, it is a temporary structure, a 'rig', the provisional character of which is emphasised by its open form and apparent incongruity as architecture within architecture.

1 Liam Gillick interviewed by Barbara Steiner [unpublished].
2 Liam Gillick, *Big Conference Centre*, exh. cat., Kunstverein Ludwigsburg and Orchard Gallery, Derry, 1997, pp.92–3.
3 Liam Gillick interviewed by Alan Phelan, Sculpture Society of Ireland 1997 [unpublished].

My work is not concerned with beginnings or endings, but the space between objects, images, ideas or units. There is always a middle from which the work overspills and grows.[1]

The title of Brighid Lowe's work shown in *Intelligence, I Saw Two Englands Breakaway* (1996–7) seems to refer to its two elements: a single text and a landscape of books, both mounted on the wall. Equal in size, these two elements are positioned on opposite walls so that the viewer occupies, both physically and mentally, the space in between. The books are evenly spaced in the form of a grid, with their covers facing out. Forming a giant puzzle of images and words, they pulsate with colour and intrigue, each design competing for attention. Books, like records, are collector's items, but what might this collection reveal about the artist? The title of this work also suggests a real or imagined rift, release or liberation, of a place, idea or state of mind.

The idea to create a text using book titles came almost accidentally when Lowe saw two titles whose chance juxtaposition seemed to make sense. Later, she recalled a scene from Jean Luc Godard's film *Une Femme est une femme* (1961), in which two lovers argue by grabbing books from shelves, using their titles in place of speech. Over a period of eighteen months she collected 500 books, trawling charity shops, car-boot sales and second-hand bookshops. The books,

mostly mass-produced paperbacks, were chosen primarily for their covers rather than their titles. Lowe then selected and arranged 225 of these found objects into a grid, so that their titles, if read by the viewer from left to right, would construct a single, continuous text. The artist has described what begins to occur when the titles and covers of the books are arranged against one another:

> The images of the battered, second-hand covers sometimes work with the text — with prophetic reinforcement, and sometimes against the text — cartooning its intensity; so that reading the book covers continuously inflates and deflates the rhetoric of the text.[2]

The text produced by the sum of the book titles is vivid, raw, and at times surreal:

> Do you remember England how to study the treason line? It couldn't matter less. You've got it coming Britain. On borrowed time, the empty hours swimming in cold blood, anxiety and neurosis, this animal is mischievous. No more murders. Time to grow scales of justice, interface

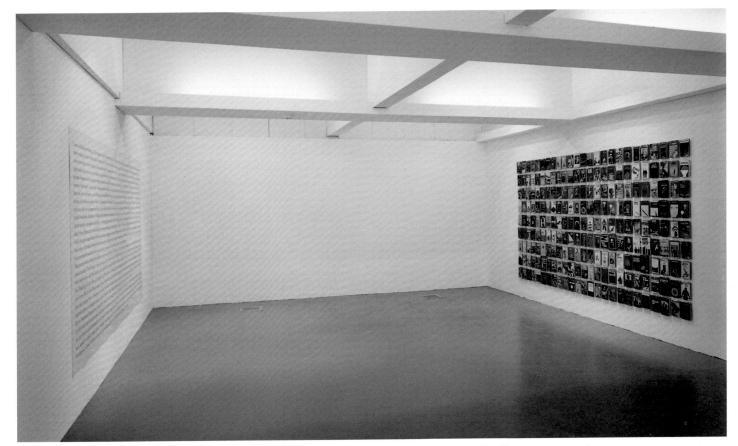

fig.35 *I Saw Two Englands Breakaway* 1996–7, 225 books, 450 Perspex mounts, C-type on flexibase. Installation at John Hansard Gallery, Southampton 1997. Courtesy the artist

language in thinking, seize the day — you can always duck the assaults on our senses. Let me commend the last enemy — our language; the deviator slave's revenge.

Yet it has the force and conviction of a political declaration, or an avant-garde manifesto. For Lowe, the text is informed by her own experiences and feelings and is primarily concerned with the politics, ideologies and betrayals of contemporary Britain. The meanings of the text are inflected through the books themselves, through their histories, the language of their titles and their genres — populist, mass-consumption thrillers and horror books; 1960s and 1970s books on education and sociology; self-help books and evangelical books. As worn, second-hand publications, they embody residual value systems and redundant aspects of our culture that remain in circulation.

By piecing together these pre-existing words Lowe points to, and at the same time attempts to deal with, the difficulty of voicing dissent in an environment where established oppositional ideologies, such as socialism, communism and feminism have been undermined or swept aside. On this issue, she has referred to the French philosopher Gilles Deleuze, who has written:

How does one speak without giving orders, without claiming to represent something or someone, how does one get those who don't have the right to it to speak, and restore to sounds their value of a struggle against power? That must be it: by being like a foreigner in one's own language, making a sort of vanishing trace of language.[3]

For Lowe, the process of making the text was both liberating and constraining. The titles provided endless possibilities, yet

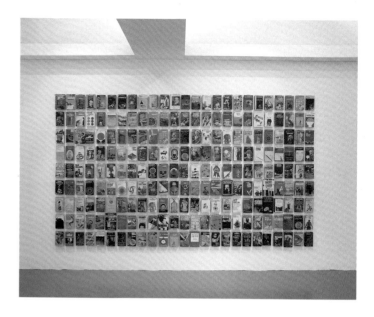

figs.36,37 *I Saw Two Englands Breakaway* 1996–7 (details),
John Hansard Gallery, Southampton 1997

dictated the texture and limitation of her
expression. She has observed:

> The 'voice' of the final text belongs
> both to its author and to the books them-
> selves, it was literally as if I was a
> foreigner in my own language. The text
> has the appearance of having written
> itself, the books seemingly composing
> themselves at their own dictation. The
> books, and the text generated from their
> titles are mutually dependent upon each
> other, but they are never the same,
> they are constantly oscillating between
> equivalence and difference.[4]

Through her work, Lowe attempts to rupture
and destabilise boundaries and locations.
She has commented: 'The work is intended to
present fragments and traces in constant
contact and attrition with each other
rather than any neat fencing off or framing.'
The books used in this piece are familiar
objects, their titles often clichés. But,
by placing the covers together, Lowe forces
language 'against itself' and creates a
space — both literally and mentally — into
which viewers must locate themselves.

1 Brighid Lowe, unpublished paper, 1997, p.1.
2 Ibid., p.2.
3 Gilles Deleuze, *Three Questions about 'Six Fois Deux'*,
in *Jean-Luc Godard: Son + Image*, Museum of Modern Art,
New York, 1992.
4 Lowe 1997, p.4.

I put myself in a position where I have to improvise. In a similar way to a jazz musician, I am working with the attractions (themes, if you like) that I'm interested in at a particular time. I like to put myself on the edge of the work where the pre-existing situation and this range of attractions combine to make the show. I think the best work has been when the time limit, the space or my immediate feelings allow things to pop up that can't be fully assessed.[1]

Most of Richard Wright's paintings are made directly on the wall of the gallery. They are designed and executed on the spot, last for the duration of the exhibition and are then painted over and erased. This method of working places a huge onus on the artist himself, working at a particular time and space, to find a combination of elements that find a resonance with the environment. To define this resonance is difficult, but Wright's intentions include a desire to change the atmosphere and perception of a room with the addition of a minimal number of elements. He is also concerned that the work does not call too great attention to itself, that it

> would be seen not as painting but as
> something unloaded, as interesting
> as it was meaningless — to appear like
> it had always been there or has some
> other purpose.[2]

His project is, in some senses, a modest one. Yet its motivation — to inject painting with a more immediate and less loaded historical sense of itself — can have far-reaching implications. Wright's subject could be said to be the history and status of painting. His knowledge of that history

fig.38 Work from *Pure Fantasy: Inventive Painting of the 90's*, Oriel Mostyn, Llandudno, 1997, gouache. Courtesy the artist / The Modern Institute, Glasgow

is outstanding, and something he uses to great effect in the work. Nevertheless, it is an overt rejection of the historical weight of painting's tradition that necessitates the forms taken by Wright's work. He observes that this history obscures the view of a traditional oil on canvas, creating a difficulty for the viewer to see beyond it, to encounter the work unexpectedly. A specific painting might become almost invisible in the face of a too great familiarity with the form. To avoid this, the portable nature of the work has to be removed, so that the physical context of

fig.39 Work from *Manifesta 2*, Luxembourg, 1998, gouache.
Courtesy the artist / The Modern Institute, Glasgow

gallery architecture with all its quirks and irregularities becomes a part of the conditions for seeing the art. For instance, a work might draw a formal analogy with a light switch or movement detector already located nearby. In more complex works, a series of wall paintings might draw the viewer to a particular point of view in the gallery from where an overview or a sense of each work's mutual dependency can be gained. These aspects combine to produce an investigation of the surrounding environment as well as a concentration on the image on the wall.

At the same time, the work probes Wright's own wide frame of reference, drawing on the history of painting but also quoting forms of design and consumer packaging, computer graphics and medieval manuscript illumination. For a viewer who encounters his work for the first time, these references might appear quite arbitrary, but after seeing a number of pieces, a certain consistency emerges. 'Dungeons and Dragons' fantasy games, electricity industry graphics, biker-jacket motifs and other signifiers of outsider lifestyles, along with symbols used to represent scientific models, all appear repeatedly. Their presence signals a flattening of hierarchies between high art and commercial design in the subject matter, while the painstaking process of making the work creates a tension through which assumptions about the value of the handmade and the skilled exercise of the body are tested. Wright has spoken about the 'dumbness of painting' in this regard; the way in which a very simple series of marks can create the illusion of perspective or figuration in the mind's eye. Our human urge to identify meaning in form and colour is the subject here, though the pop cultural references serve to resist more pretentious interpretations of the work. In fact, this oscillation between the claims of (modernist, abstract) painting to be a universal expression and the source of the imagery itself mirrors the optical oscillation that the works often generate in the eyes of the viewer. The experience of the work eventually rests somewhere between intellectual interpretation and a kind of visual or physical understanding.

Intelligence includes a number of individual works by Wright, dispersed through the exhibition. In a similar way to Alan Johnston's wall drawings, these paintings will act as reminders for a way of thinking and of attending to details and conditions usually ignored. Their importance for the exhibition is precisely this, to confirm at intervals throughout the show the idea of an active viewer, engaged in the mechanics of looking and interpreting the works in the exhibition.

1 Richard Wright interviewed by Charles Esche, *Artists' Newsletter*, April 1998, p.12.
2 Ibid.

fig.40 Work from *Manifesta 2*, Luxembourg, 1998, gouache. Courtesy the artist / The Modern Institute, Glasgow

thought could be realised as plastic and tactile, that is, an activity that takes place in the body, and is of the body. Art is, then, a kind of investigation into the nature of reality; it is a form of knowledge whose outcomes are visible, touchable, material and actual.[1]

Alan Johnston's work is, at times, almost invisible — but then 'almost' is not invisible at all. At a time when our lives are saturated by commodified images, looking at a simple drawing that relies so much on what we, as viewers, might bring to it, becomes a test not just of our perception but of our whole system of value. What we see, how we see it and even whether we register it at all are consciously determined — a mirror of our private self in a way — and a measure of our understanding of order, space and structure. It is the economical way in which this act of self-awareness is achieved that makes Johnston's work so extraordinary and quietly effective.

Johnston's wall drawings take the form of short irregular pencil marks, closely interwoven to form recognisable geometric shapes. The shapes take their lead from the walls and spaces around them, heightening our awareness of the architecture and surroundings more than the presence of the work itself. Held within these geometries is another shape, a negative or void space, that emerges only because of the pencil shading around its perimeter. This area holds the key to an intention in all Johnston's art. Those who are attuned will see not just a frame, but an internal shape looking back out at them. Having been defined by its edges, it can now take on an identity of its own, an independent existence that is no longer part of the wall from which it came. This is a creative, almost magical act, difficult to see in a single glance. What is more, these negative, untouched areas of the work not only come into a sense of themselves, but equally serve as screens for our own projections. The emptiness of the plane of white permits an immediate consciousness of the ambient quality of vision. Like John Cage's famous *4 Minutes 33 Seconds* (1963) of silence when the ear becomes painfully aware of all the ambient noise in the concert hall, so with Johnston's voids; the eye betrays itself as full of its own created images. Unstoppable twisted shapes, not dissimilar to Johnston's own pencil lines, float across the retina; detailing of surfaces, fixtures and incidental events take on new significance. Much that was previously invisible becomes apparent. This physiological interpretation of the work as a betrayer of the viewer does not confine its meaning. The screen defined by the drawing can also be looked at cinematically, as a surface made ready for projection. The source, however, is not the mechanical

fig.41 *Wall drawing* 1999, pencil. Site-specific installation, Riehen Basel

apparatus of the film projector but the thoughts and images of the viewer, already held in the mind but perhaps not made external until given the opportunity to be visualised by Johnston's drawings. The work might then be conceived of in terms of latency, the potential inherent in the viewer but only released under certain specific circumstances.

Johnston's recent works on board take this cinematic analogue even further. The painted image is again geometric, this time created from gesso and charcoal on wood; the void is again delineated by the painting, but here a Perspex frame in front of and around the work reflects (or projects) an image of the surrounding space and the features of the viewer onto the surface. The significance of the reflection draws its inspiration from the philosopher David Hume's *A Treatise on Human Nature* (1739) where he describes the nature of human relationships: 'The minds of men are mirrors to one another only in so far as they are accompanied by a reflection, of which custom renders us insensible'. It is this insensibility, both in terms of the body and the mind, that Johnston's work seeks to transform into awareness. To do so requires that the material of the work and its presence in the space should be at the edge of perception. It is only in that state of alert, questioning concentration — senses alive to the slightest change — that this transformation may take place.

A further series of window drawings completed in Basel in 1998 focuses the attention wider, the window becoming not only only an empty field, but a way of reframing the world beyond and around its transparent

fig.42 *Window Piece* 1999, transparent laquer. Site-specific installation, Diener & Diener, St Albantal, Basel

surface. The photographs of these works include the mundane detail of life in an office or an apartment block stairway, recognising the everyday alongside the space for utopian projection.

Johnston's work is undoubtedly demanding on the viewer, requiring a self-analysis of the clarity of our individual perception and a rigorous testing of the visual intellect. It makes explicit the complex connection between mind and eye, sight being the sense that triggers the most widespread response in different areas of the brain and hence arguably our primary faculty for comprehending the world. A careful sense of dualism in the drawings and paintings — between light and dark or form and void — relates to a similar accounting in the work of fellow Scots, Douglas Gordon and Martin Creed. This reflects a shared concern for an economy

of production and for a desire to retain a certain ambivalence towards their subject matter — an approach that mirrors other aspects of Scottish culture. To this extent also, Johnston's austere images serve as a guide to the types of inquiry that might be demanded by other works in *Intelligence*. It is not ideological certainty that guides the artists here, but a sense of a deeper inquiry into human conditions, without clear solutions and without end, except in a temporary form of resolution that each viewer may find within themselves.

1 Mel Gooding, 'The Radiant Mirror', in *Alan Johnston Haus Wittgenstein*, Inverleith House, The Royal Botanic Garden, Edinburgh, 1999.

Hilary Lloyd's videos arise from what might be described as a love affair with her subjects. The work evolves over a period of time, relying on the relationships she forms with strangers, people whom she encounters by chance in the course of everyday life. She approaches individuals out of curiosity, or simply because something about their look appeals to her. All of her collaborations involve some kind of performance in front of the camera, and seem to explore the interplay between performance and personal identity and the often voyeuristically charged relationship between performer and viewer. Although Lloyd controls the presentation of her work, there is an ambiguity about her role in determining the content of her films, which often depends on the ingenuity and enthusiasm of her subjects and their willingness to collaborate with her. This element of unpredictability gives rise to an unformulaic quality.

The subtle eroticism of Lloyd's work perhaps stems from a perception of the sexual undercurrents of daily urban life. Lloyd has been drawn to people engaged in urban subcultures, such as roller-bladers, skateboarders and nightclubbers. Filmed in real time and often unedited, her videos

fig.43 Installation view, Chisenhale Gallery, London, 1999
Courtesy the artist

present the viewer with a sense of underdeveloped narrative, dwelling on the banal activities that might fill a day. *Ewan* (1995), for example, features a DJ from south London and comprises two monitors placed back-to-back. One of these shows the subject selecting and playing records in his bedroom in preparation for a set later that evening in a nightclub, while his evening performance plays simultaneously on the other screen. Here, as in other works, Lloyd seems fascinated by the (now often blurred) distinctions between leisure and work, and by the abrupt accelerations

fig.44 *Maddy and Kate* 1999, video still. Courtesy the artist

and decelerations in the way time is experienced within the context of urban lives.

The artist has developed a way of presenting her videos that both highlights the individuality of each film and maximises the physical impact of the work on the viewer. For a recent solo exhibition at Chisenhale Gallery, London, she presented seven separate videos. Placed on professional display stands with their cables and wires visible, the video monitors functioned like sculptures, articulating the space of the gallery. Carefully positioned in relation to each other, they set up a series of contrasting relationships for the viewer to consider. Juxtaposed in this way, the individuality of each film became apparent.

Though disparate in subject, style and pace, the combined sound, movement and lush colour of the group as a whole created a seductive, choreographed rhythm, akin to the rhythms of the human body, the viewer's body. For Lloyd, the engagement — often indeed the voyeuristic complicity — of the viewer is as important as the collaborative relationship that produced the work.

Together, these videos draw attention to movement, contrasting various images of frenetic activity and stillness: the rapid, impulsive movements of skateboarders skimming across the ground; a woman sitting motionless in a model's pose; a man slowly taking off and putting on his t-shirt; groups of construction workers lifting each

other like circus acrobats to make structures out of their own bodies; two women unravelling a large ball of string; a hypnotic, one-minute loop of rippling water. A rhythmic background like a constant heartbeat is provided by Fiorenzo, a slender youth filmed banging cardboard tubes against a dilapidated wall. As Alexander Bradley has observed:

> The exhibition layout seems intent on drawing out a relationship, albeit subliminal, between the human, physical subjects as portraits and the technical, audio-visual body of equipment as a whole.[1]

All of the people depicted are doing something, all seem to be concentrating. Their activities vary in tone — comic, cathartic, self-conscious, uninhibited, disciplined, puzzling — but through the intensity of their absorption, and the subtlest of means, each incident on screen produces a certain tension. Lloyd employs such techniques as minimal editing, long takes and static camera shots, which cumulatively have the effect of distancing the viewer from otherwise familiar scenarios. Sometimes she achieves a peculiarly static, painterly quality, as in *One Minute of Water* or *Colin #2* (both 1999), in which the subject is shot in profile, his precise, pared-down movements mimicking the distancing effect of slow-motion film. By contrast, *Landscape* (1999) comprising footage taken of the ground by skateboarders as they speed along, gives the impression of a landscape in constant motion. Following Lloyd's realisation that there are skateboarders in almost every town in Britain, this piece edits together footage taken in cities from Brighton to Birmingham, from Bristol to Milton Keynes.

Using techniques established by Andy Warhol such as the fixed, deadpan camera, Lloyd elicits performances that reveal both the pleasure and the discomfort of being observed. In *Constructors* (1999), for

fig.45 *Dawn* 1999, video still. Courtesy the artist

example, groups of construction workers balance, prop and lift each other to build human structures. Some obviously enjoy exhibiting themselves, but as the camera lingers, they become self-conscious. The improvised feel of their performances and their apparent insecurity suggest that they are awaiting instructions from the artist behind the camera (and are perhaps embarrassed to be taking their orders from a woman).

Polly Staple has summed up the relationship between viewer and subject in Lloyd's work:

> Lloyd's videos articulate the engagement between the voyeur and the performer, between watching and being watched, intimacy and distance, wilfulness and self-control. This high degree of self-consciousness seems a particularly urban trait, it stems from moving — *flaneuring* — through the city, and articulates the paradoxical relationship between the desire to connect and the need to protect yourself.[2]

1 Alexander Bradley, 'Hilary Lloyd', *Art Monthly*, Nov. 1999, p.231.
2 Polly Staple, 'Precious Time: Polly Staple on Hilary Lloyd', *UNTITLED*, spring 2000, p.9.

Overheard conversations and human incidents, casually observed, often provide a starting point for Jaki Irvine's work. She weaves these real events with fictitious narratives to produce haunting, disarmingly understated Super-8 and 16mm films. Typically, she exploits the potential discontinuity between the three main elements of her films — moving image, musical score and narrator — to undermine any sense of a linear narrative. Focusing on the human subject, her films suggest the fragmented, mysterious and absurd nature of the human condition. Reflecting on such experiences as desire, loss, fear, obsession and memory, Irvine exposes the gap between what is seen, heard and perceived. The artist has commented on her interest in exploring

those points where what at first seems most available to understanding, slowly turns opaque, revealing itself as misleading or meaningless. If this then opens out a sense of untold distances between things, and people, it also brings with it a desire for the reverse, gesturing towards impossibly compensatory intimacies between ourselves and the world … towards a belief in the transparency and agreement of things — of

gestures, smiles, meanings, chance remarks and strangers.[1]

The romantic obsession central to *Eyelashes* (1996), together with the low-key look of the film, brings to mind the intimate films of Eric Rohmer, particularly *The Green Ray* of 1986, which follows the fortunes of a young woman on holiday by the sea, seeking a soul mate. She becomes obsessed with a desire to see the green ray, a rarely visible light that appears in the sky when conditions produce the right refraction. The green ray represents both a surrogate love object and a symbol of hope in her search. In Rohmer's film, the woman wistfully attaches meaning to incidents and things, in an effort to convince herself that her desires will be fulfilled, to create certainty where there is none.

Irvine deliberately rejects the manipulative strategies of conventional cinema. Nevertheless, using disjunctural techniques, she constantly attempts to question/unsettle the position of the viewer. The slippage between the evidence of what is seen and heard undermines certainty, teasing the viewer into a place somewhere in the middle. Shot on Super-8 and presented as a video projection, *Eyelashes*

fig.46 *Eyelashes* 1996, 8mm film still. Courtesy the artist and Frith Street Gallery, London

is apparently a story about a man's unaccountable obsession with a woman's eyelashes. A misleading establishing shot of a building with an institutional air, perhaps a school or hospital, together with a portentous soundtrack — Thomas Oboe Lee's *Morango, almost a Tango* — creates a sense of expectation totally at odds with the banality of the scene of a man and a woman having a conversation over breakfast. The woman glances furtively and self-consciously at the camera. Nevertheless, she smiles at the man opposite her, as if to put him at ease. The man, seen in profile, speaks animatedly and gestures as if to convince the woman of something. All the while the accompanying voiceover, a woman speaking in heavily accented English, tells of a man who is troubled by a pair of eyelashes: 'They just hang around her eyes in an anonymous casual kind of way that makes him uneasy.' But the woman's face is not shown in close-up — there is no proof

that her eyelashes are the object of desire. Instead, the camera dwells on such details as the man licking his lips or twitching his foot. Poetic and passionate in content, the narrator's account is delivered with the measured intonations of a reporter. The flickering graininess of Super-8 film suggests an earlier time; the 'foreign' voice evokes another place. Yet there is evidence to the contrary: a familiar milk carton, for example, stands discreetly on the kitchen table. Filmed in real time, with the awkwardness and sometimes irritating unsteadiness of a home movie, *Eyelashes* is less immediately lyrical than much of Irvine's earlier work. Its apparent visual banality works against the voiceover, which exerts an increasingly obsessive grip on the listener: 'After a while it becomes clear that those eyelashes are holding his imagination hostage.' As curator Caoimhím Mac Giolla Léith has observed:

fig.47 'Dani and Diego', *The Hottest Sun, The Darkest Hour* 1999, 16mm film still. Courtesy the artist and Frith Street Gallery, London

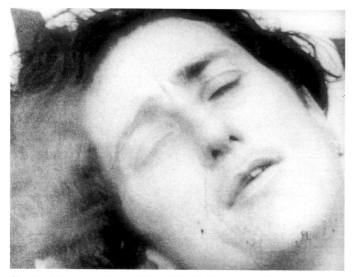

fig.48 'Portrait of Daniela', *The Hottest Sun, The Darkest Hour* 1999, 16mm film still. Courtesy the artist and Frith Street Gallery, London

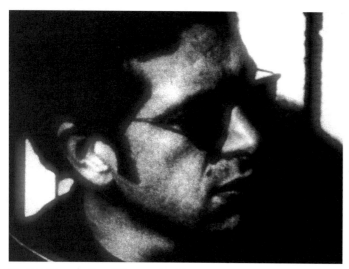

fig.49 'Marco, One Afternoon', *The Hottest Sun, The Darkest Hour* 1999. 16mm film still. Courtesy the artist and Frith Street Gallery, London

The text flirts outrageously with the viewer as the woman's eyelashes are compared, for instance, to 'a small carefully constructed crowd scene that has two or three spies concealed in it'. Music and text pile on charm from which the imagery at first seems guilelessly free. What initially presents itself as an analysis of seductiveness, gradually becomes an act of seduction'.[2]

In recent years, Irvine has begun to group films together, creating more complex narrative possibilities and interconnections. For example, *The Hottest Sun, The Darkest Hour: A Romance* shown in 1999 at the Douglas Hyde Gallery, Dublin, comprises five loosely related black and white films. These were made over a two-year period, between London and Italy, where the artist is now mostly resident, and can be read as meditations on the nature of intimacy, memory and the seductions — and estrangements — of language. Typically, they are redolent of another time and other places. However, Irvine's preferred distancing devices of the accented voice-over and worn black and white image are here offset by a cumulative sense of raw emotion and sensuality.

1 Jaki Irving quoted in *IMMA/Glen Dimplex Artists Award*, exh. cat., Irish Museum of Modern Art, Dublin, 1996, p.10.
2 Caoimhím Mac Giolla Léith, 'Jaki Irvine: The Project Arts Centre', *Flash Art*, Nov.–Dec. 1996, p.109.

For those of us who dare to desire differently … the issue of race and representation … is about transforming the image, creating alternatives, asking ourselves questions about what types of images subvert, pose critical alternatives, and transform our worldviews and move us away from dualistic thinking about good and bad.[1]

Oladélé Ajiboyé Bamgboyé is one of a number of British artists of Nigerian origin or descent to have emerged in the 1980s and 1990s, including the late Rotimi Fani-Kayode, Yinka Shonibare, Chris Ofili and Olu Oguibe. The latter has described how these artists have embraced their dual identity as a positive condition:

> These artists do not perceive themselves as cultural ambassadors any more than do their Western contemporaries. They reject the burden of ancestry and ethnicity as a matter of fact. Having come through multiple circumstances, they lay claim to the entirety of their experiences and consider themselves as much part of their societies of relocation as any others. Among their contemporaries, they suffer the affliction of never being discussed without some reference, no matter how benign, to their 'stranger status' … To contend with such circumstances, these artists carry with them a pronounced sense of self-awareness and clarity, and determination to ensure that they are at home in the world.[2]

This appears to be true of Bamgboyé, whose work is informed by a subtle and idiosyn-cratic spirit of enquiry. Using himself as a subject, in his early photographs he attempted to convey a sense of disjuncture between his body and its surroundings, his contorted figure at odds with the reassuring normality of a domestic environment. He began making films in 1993 and during the mid-1990s produced a number of short films that investigate the nature of subjectivity within society. *Spells for Beginners*, made in 1994 but shown for the first time in *Intelligence*, is a quietly affecting 16mm film featuring himself and Scottish artist Anne Rome Elliot, with whom he had a long relationship. The couple appear separately in a sequence of shots — she in a domestic space, head in hands, or outside against a blank white background of snow; he seated on a sofa, then naked and taking a bath. These images are viewed in conjunction with their tense and painful (unscripted) conversation, which gropes towards some understanding of why their relationship ended. This type of confessional material ought to be familiar, forming as it does the staple content of women's magazines, TV chat shows and docu-soaps. But *Spells For Beginners* is altogether more poignant, exposing the complex meshing of individual experience with the strictures and prejudices circulating

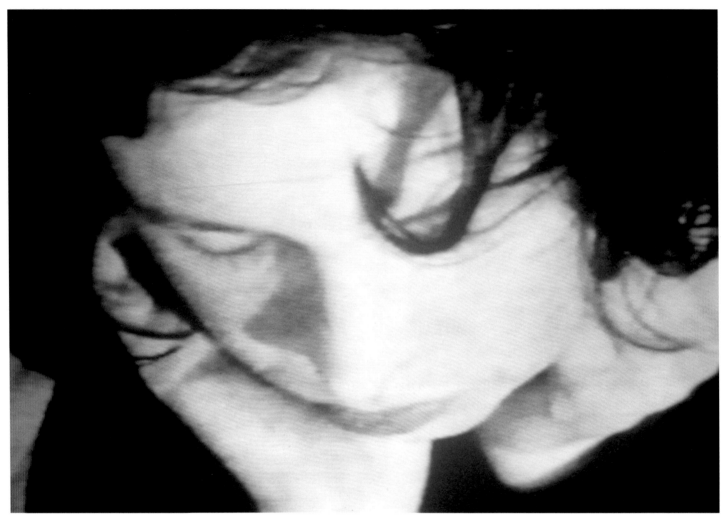

fig.50 *Spells for Beginners* 1994/2000, video still. Courtesy the artist

in the wider cultural and social environment. The failure of the affair is difficult for both parties. They seek answers, but there is no sense of blame.

The opening shot shows Bamgboyé reflected in a mirror as Elliot declares that he was always her 'showpiece': she could never escape from the social implications of their liaison. In the context of the predominantly white society of Scotland, the issue of race constantly framed their affair, causing her always to doubt her real motives. She concedes that the relationship had revealed an unintentional, yet deep-seated racism on her part.

One sequence casually juxtaposes Bamboyé's naked torso with images of nudes on the wall. Among them is a postcard of a reclining female nude by Modigliani, perhaps a deliberate reference to the history of the appropriation and fetishisation of the non-Western, 'primitive' body, a clue to the seemingly insurmountable cultural and social baggage that confounded the artist's ex-lover. The film might be read as exposing the widespread objectification of the black male body in the West. Images of Bamgboyé climbing into his bath perhaps play to the myth of supercharged black sexuality. This myth, developed over several hundred years from a mixture of desire and fear of black men, is underpinned by the blatantly racist notion of Africans as carnal rather than cerebral beings. But this potentially voyeuristic moment is punctured by the emotional, yet intelligently enquiring, dialogue between two people seeking some understanding of what has happened.

Spells for Beginners brings together two central themes that have preoccupied Bamgboyé over the last decade, namely, the representation of black masculinity, and the dual consciousness of the immigrant who, drawing on memory, constantly attempts to reconstruct a sense of place and self.

By presenting the film on a large TV set in front of living-room furniture, Bamgboyé emphasises the domestic intimacy of the narrative he presents. The closing shot

fig.51 *Das Lichthaus* 1989, archival silver gelatin print. Courtesy the artist

shows his hand stretching out to pick up a book placed in front of the mirror. Titled *Spells for Beginners*, this publication about alchemy hints at the artist's belief in the transformative power of art as a tool for imagining the world otherwise.

1 bell hooks, quoted in *Black Male: Representation of Masculinity in Contemporary American Art*, exhibition booklet, Whitney Museum of American Art, New York, 1994, p.14.
2 Olu Oguibe, 'Finding a Place: Nigerian Artists in the Contemporary Art World', *Art Journal*, vol.58 no.2, 1999, p.41.

I hate conclusive things … once a piece
of work is conclusive, it's dead. The
mind should be allowed to travel and have
fantasy and imagination.[1]

fig.52 Photograph by Richard Okon of shop window with fabrics
in Brixton, London

Hovering just above eye level on a plat-
form, apparently defying gravity, stands a
nuclear family of four astronauts, equipped
for an interplanetary outing. But their
spacesuits are not fashioned, as expected,
from the silvery material used on catwalks
since the 1960s as a signifier of futuris-
tic space-age living, but from startlingly
coloured African textiles. The juxtaposi-
tion of these two seemingly incongruous
elements and the meanings they carry —
affluent modern lifestyles and 'primitive'
traditional craft — is a key strategy in
Shonibare's work. Art historically, the
technique might be traced to Surrealism, to
The Treachery of Images (1928), Magritte's
iconic picture of a pipe with the caption
'Ceci n'est pas une pipe'. More importantly,
it derives from the world in which we live,
and from Shonibare's desire to make sense
of his place within it.

 Typically of Shonibare's work, *Vacation*
is an ambiguous representation of a famil-
iar subject, that resists a single reading.
He seeks to generate a plurality of mean-
ing, often drawing attention to the shift-
ing and constructed nature of identity,
and the unsustainability of the dearly
held but slippery notion of authenticity.
His inquisitive approach accepts nothing
at face value, engaging with issues of race
and cultural stereotyping while pointing
to the contradictions inherent in essen-
tialist ideas about identity. Shonibare
has commented:

 Is there such a thing as pure origin?
 For those of the postcolonial generation
 this is a very difficult question. I'm

fig.53 *Disfunctional Family* 1999, wax-printed cotton textile. Courtesy Stephen Friedman Gallery, London

bilingual. Because I was brought up in Lagos and London — and kept going back and forth — it is extremely difficult for me to have one view of culture. It's impossible. How do I position myself in relation to that multi-faceted experience of culture?[2]

Though seemingly effortless and highly aestheticised, Shonibare's works are the result of meticulous historical research. Such research led him, for example, to substitute conventional art materials with African fabric. Though it might be taken as a symbol of ethnic authenticity, the hybrid history of the so-called 'Dutch wax' print renders it problematic as a signifier of any narrowly defined African identity. It originated in Indonesian batik techniques, which were later industrialised by Dutch colonisers. These manufacturing processes were then copied by the British, who began exporting prints from factories in Manchester to West Africa, where — ironically — they became popular in the 1960s as part of a postcolonial euphoria and celebration of African identity. Shonibare has commented on the popularity of Dutch wax fabrics among black British youth. In Brixton, for example, where he purchases the materials, they are used for headwraps, robes and shirts, as public displays of cultural affiliation: 'But the essentialism they associate with the fabrics is actually a myth because their origins are already questioned.'[3] Shonibare shows the fabric to be both fake and authentic, readymade and original.

Vacation takes on the idea of space travel as a potent escapist — and sometimes crudely expansionist — fantasy. When Armstrong walked on the moon in 1969, it

fig.54 *Sun, Sea and Sand* 1995, mixed media (detail). Installa
tion at Battersea Arts Centre, London. Courtesy Scottish
National Gallery of Modern Art, Edinburgh

seemed that mankind might indeed be
encroaching on Star Trek's 'final frontier'.
The excitement surrounding the moon land-
ings has not been repeated, and teleporta-
tion remains a distant prospect, but the
idea of space tourism is now coming under
serious corporate scrutiny (studies in
Japan and the United States predict that
it could become a billion-dollar business
within a few years). Shonibare conflates
such aspirations — to boldly go on holiday
where no man has gone before — with subtle
echoes of earlier forms of colonialism.

On another level, *Vacation* extends an
invitation to the viewer to travel freely
in the realm of the imagination, the realm
of other possibilities, unhampered by the
weight of received ideas and perceptions.
This is often the desired goal of a holiday:
the tourist destination is a place where,
away from the dulling effects of the daily
grind, the self can be recreated. *Vacation*
is one of a group of works that provoke
questions about tourism, an activity that
is sometimes taken for granted. In an
earlier work, *Sun, Sea and Sand* of 1995,
comprising 1,000 paper bowls wrapped in
African textiles and placed on a blue
floor, Shonibare alludes to the way in
which many Third World countries are becom-

ing increasingly dependent on the largesse
of affluent Western tourists, who treat
such 'exotic' holiday destinations as
backdrops for escapist fantasy, while
transforming non-Western cultures into
the stuff of airport souvenirs.

In its depiction of the family unit and
its engagement with the theme of space,
Vacation relates to an earlier series of
work that played on the notion of the
alien. Aliens as malevolent creatures from
outer space, endowed with superior intelli-
gence, gained a grip on the popular imagi-
nation following Orson Welles' broadcast of
H.G. Wells' *The Wars of the Worlds* in 1938.
But the word retains its older and wider
sense of foreign, or 'other'. Its use, for
example, in the sphere of customs and immi-
gration still suggests racial difference.

Despite its seductively sumptuous and
often playful aspects, there is a poignancy
in Shonibare's work, and a sense that some-
thing almost indefinable has been lost. In
his in-depth article on the artist of 1995,
Kobena Mercer concludes: 'As ideologies of
otherness exhaust themselves in an era
of increasingly global interdependence,
Shonibare has fun making a mockery of the
artifice of authenticity'. He follows this
statement with a quote from the artist:
'Actually, I'm not angry, I have no authentic
expression to offer'.[4]

1 Yinka Shonibare quoted in Nancy Hynes, 'The Fop's Progress',
Untitled, no.17, 1998, p.15.
2 'Art that Is Ethnic in Inverted Commas: Kobena Mercer on
Yinka Shonibare', *Frieze*, issue 25, 1995, p.40.
3 Ibid., p.41.
4 Ibid.

fig.55 detail from *An Oak Tree* 1973,
metal, glass, water (glass shelf,
glass tumbler, 2 chrome brackets)
and 6 framed texts. Courtesy the artist.
Collection of the National Gallery of
Australia, Canberra

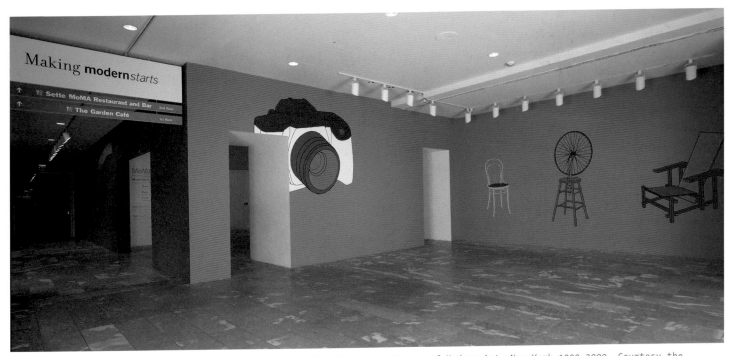

fig.56 *ModernStarts: Things* 1999–2000, site-specific wall painting at Museum of Modern Art, New York 1999–2000. Courtesy the artist and Waddington Galleries

When faced with a series of lines, colours, patterns, shapes, our cognition cannot help but try to make sense of the confusion. This will to order that characterises human intellectual activity is teased out by the work of Michael Craig-Martin. His large colourful wall paintings both make explicit and confound the activity of looking, emphasising the visual at the same time as they force an appreciation of the connection between looking and thinking, figuring things out and feeling our way into the space of the room and the work. Craig-Martin's new work for this exhibition continues a line of inquiry into the parameters of representation that has characterised his practice since the mid-1960s. Although passing through many changes of

material and apparently radical breaks, his
work has consistently sought to disturb
the assumed reliability of perception and
visual 'readings'.

For *Intelligence*, a mass of black line
drawings resolves into a series of identi-
fiable, everyday objects including ladders,
filing cabinets, fire extinguishers, lamps
and globes. Each object is depicted in a
three-dimensional rendition somewhere
between iconic illustration and detailed
architectural model. There always seems
to be just sufficient information for the
object not only to be identifiable but to
take on a character of its own, a point of
balance that is impossible to define but
instantly apparent. Although made from a
black and white outline, it is almost too
easy to ascribe colour instinctively to
each object — red for the fire extinguisher,
blue for the globe, dark green for the
raincoat and so on. This collection of
things, each with its own potential
metaphoric reading, forms the backdrop to
a series of coloured objects, some repeated
from line drawings, others unique, that
occupy the corners and centre of each wall.
These items combine the functional refer-
ences of the background with allusions to
art works or film clichés. A bottle rack
sits in the corner, next to red-tinted sun-
glasses evoking sleazy West Coast B-movies.
Man Ray's beautiful Surrealist iron with

spikes hovers above the door next to a fire
extinguisher and an overfilled tin of
paintbrushes — all objects, save the iron,
with possible use value and all, in mater-
ial terms, representations in acrylic paint
on partition wall.

Craig-Martin's work leads us on. The
directness of the perspective drawings and
the lack of expressive elements cause us
to think about the nature of the things
depicted rather than the nature of their
representation, though the latter can never
be ignored. The four corner objects are
round: they both deny the architecture and
support it as columns. They represent in
turn useful objects and art icons, Duchamp's
bottlerack, Johns' can of paintbrushes, a
wineglass from a Magritte painting, and
Craig-Martin's own fire extinguisher. All
have been compromised or subverted by the
colours. The four elements floating in
the centre of the walls each hold some ele-
ment of threat: the sickle (political),
sunglasses (psychological), the drill
(DIY torture), and the iron (dangerous
art). These potential readings result in
a certain visual and cognitive tension,
emphasised even more by the sheer overload
of images in the background. Colourful
and at the same time oppressive, the work
exploits the constant search for recogni-
tion that neuro-scientists are finding
at the core of the visual brain. As neuro-
biologist Semir Zeki puts it:

Vision must therefore be an active
process requiring the brain to discount
the continual changes and extract from
them only that which is necessary for it
to categorise objects. This requires
it to undertake three separate but inter-
linked processes: to select from the vast
and ever-changing information reaching
it only that which is necessary for it to
be able to identify the constant essen-
tial properties of objects and surfaces,
to discount and sacrifice all the infor-
mation that is not of interest to it in
obtaining that knowledge, and to compare

fig.58 *Conference* 1999, acrylic on canvas. Courtesy the artist and Waddington Galleries

the selected information with its stored record of past visual information, and thus identify an object or a scene. This is no mean feat.[1]

In some ways, Craig-Martin performs this 'mean feat' for us. His images are reduced to 'that which is necessary to categorise objects', perhaps in a search for their constant properties, but his references to specific moments in cultural history complicate the identification. The task of actively looking is therefore directed away from simple recognition towards a reading of the object (and the object as represented in the painting) as a carrier of multiple possibilities. Mark Pimlott has described this process as follows:

The viewer is constantly asked to drop his defences: to allow things that function in one way to function in another; to contemplate use rather than simple sight (to be active rather than passive); to take things as pictures. As function is broken down, so too is the normal, the habitual, the agreement of language. Use is no longer transparent, but stumbled over and made into imaginative construction.[2]

The viewer is put into an unusual position of seductive uncertainty. The apparent attraction of seeing and identifying familiar things is thrown into question by the instability of the objects in relation to the world, neither ideal nor specific, with a perspective and application that is both full of the cleverness of modernism and slightly naive in the way of early Renaissance painting. Craig-Martin has drawn a parallel between that era of experimentation and our own. Ours is a time when perception is again open to change, technology is creating the possibility of images that were unimaginable until very recently, and the task of the artist as the constructor of forms of knowledge about the world is again possible to imagine.

1 Semir Zeki, *Inner Vision*, Oxford 1999, pp.5–6.
2 Mark Pimlott in *Michael Craig-Martin*, exh. cat., Muzeum Sztuki, Łodz, 1995, p.65.

A great deal of my work is about question-
ing handed-down truths … I'm always trying
to find ways of discovering things about
people, and in the process discover more
about myself.[1]

At the heart of Gillian Wearing's work is
a collaboration or collusion with others.
Often set on the street or in domestic
environments, her videos and photographs
concentrate on the points of friction
between public and private realms, between
individual impulse and established norms
of behaviour. Her work seems motivated by a
desire to expose genuine emotions, to get
behind the masks, the faces we cultivate
in order to fit in. In particular, she
dwells on the close and often contradictory
relationships within families, between
lovers or friends. The results are humorous,
poignant, and often problematic for the
viewer.

Inspired by pioneering 'fly-on-the-wall'
television documentaries of the 1960s and
1970s, Wearing adopts an apparently anthro-
pological, documentary approach. She
researches her subjects, gathering informa-
tion by word of mouth and through classi-
fied advertisements. Her findings are
presented as videos or photographs, the
standard tools of the photo-journalist. But
according to journalist and documentary
film-maker Jon Ronson, what distinguishes
Wearing's work from 'real-life' television
programmes is that

fig.59 *Dancing in Peckham* 1994, video still. Maureen Paley/
Interim Art, London

her morality — and the moral relationship between the chronicler and the chronicled — is central to her films … Implicit in her work is the acknowledgement that documentary is exploitation. When she becomes her subject — when she attempts to inhabit the body of her subjects … she is both striving to understand someone else's truth, and admitting that this is impossible to do.[2]

Wearing's well-known video work, *Dancing in Peckham* of 1994, is a case in point. For twenty-five minutes the artist danced in a shopping precinct to music playing only in her head, while passers-by looked on bemused, or indifferent to her aberrant behaviour. The artist has said that the idea for the piece stemmed from seeing a woman dance without inhibition in the Royal Festival Hall, oblivious to the fact that she was making a spectacle of herself: 'Asking her to be in one of my videos would have been patronising, so I decided to do it myself.'[3] Wearing was attracted by the woman's lack of self-consciousness: 'I see myself being unable to get beyond my own reservations, and a lot of my work obviously deals with me trying to go out there myself.'[4] She has admitted being drawn to misfits, people who stand outside societal norms, and has spoken of her own feelings of alienation:

I always used to feel like a foreigner in my own country, because I didn't receive a very good education. I'm more interested in how other people put things together, how people can say something far more interesting than I can.[5]

Wearing often explores notions of power and control, pushing the boundaries of the relationship between herself and her collaborators. Although she undeniably retains editorial power, she nevertheless attempts to create a space where the people featured in her work can take some control of what they say, how they are represented.

In *Drunk* (1999), comprising three synchronised projections, Wearing treads difficult territory. The footage represents the culmination of a two-year project in which she befriended a community of street drinkers in south London. Eventually, they trusted her enough to be filmed, despite initial fears that she was a police agent gathering intelligence about their habits and misdemeanours. As Wearing has often used actors, the viewer might be caught off guard, thinking at first that the raw language and rhythmic swaying of the protagonists are carefully scripted and choreographed. But the truth soon becomes apparent as the subjects lose awareness of the camera, revealing the kind of hierarchies, intimacies, fears, rivalries and aggressions that generally only children seem capable of expressing without reserve. The influence of alcohol is ever-present. It slurs speech, slows down movements, exposes hostilities. But it also enables touching displays of genuine emotion — rarely, for example, are adult men seen so unashamedly affectionate with one another.

Many of Wearing's works have explored the use of performance as a vehicle of authentic self expression. The protagonists of *Drunk*, with their lurching, slow-motion movements, seem locked into a bizarre *danse macabre*. Street-dwellers such as these are all too easy to ignore — even their alcohol-saturated attempts to engage the attention of potentially beneficent passers-by have the paradoxical effect of rendering them all the more invisible, of ensuring that eyes are hurriedly averted. But the viewer confronted with *Drunk* is no longer an irritated, intimidated or indifferent passer-by. These outsiders are presented without judgement, as a coherent society of individuals. No attempt is made to suggest the wider social context in which these lives have been shaped. Alcohol is often used as an anaesthetic, to dull pain of one sort or another, but we do not know why being 'out of it' may have become for these men and women the only means of

fig.60 *Drunk* 1999, video still. Maureen Paley / Interim Art, London

survival. It is difficult, however, not to be reminded of the effects of poverty on a whole swathe of Britain's population — detailed, for instance, in such damning reports as Nick Davies' *Dark Heart: The Shocking Truth About Hidden Britain* (1997).

Wearing removes the characters from their familiar environment, filming them in a stark, white, makeshift space. This simple device focuses attention on the individuals themselves. It is reminiscent of the mono-chrome, minimal stage sets favoured by Samuel Beckett in such bleakly objective meditations on human suffering, survival and immobility as *Waiting for Godot* (1954).

The idea for making *Drunk* stemmed from Wearing's acquaintance with a young female street drinker. Fascinated by her personal-ity, Wearing began taking footage of the woman, but before the artist could gather enough information to make a detailed film, the woman died, either of cancer or liver failure. Shocked by the woman's death and now without the central protaganist, Wearing abandoned the project. Some time later, knowing that the artist had formed a particular bond with the woman, one of her relatives wrote to Wearing, suggesting that her death may have been quickened by physical abuse. On the street people age and die young, vulnerable to the ravages of cold, hunger and neglect. The death of the street drinker goes by uninvestigated, unnoticed. So Wearing decided to make *Prelude* (2000), which in bringing together fragments of this woman's story, pays tribute to the troubled life of a unique individual.

1 'Sign Language: Gillian Wearing interviewed by Gregor Muir', *Dazed & Confused*, no.25, 1996, p.62.
2 'Ordinarily So: Jon Ronson on documentary film-making and Gillian Wearing', *Frieze*, issue 36, 1997, p.63.
3 'Sign Language', op. cit., p.55.
4 Ibid., p.62.

My idea of an audience is as broad as pos-
sible, as broad as the public. I believe
the public does like art, and their stance
against it is a part of how they like it,
they enjoy having a go at it. And I make my
work with that in mind. It plays on that.
That people are not going to like it, or
they're going to laugh, or they're going to
think it's a load of bollocks.[1]

Sarah Lucas is best known for a series of
lurid, confrontational sculptures. Combin-
ing the spirit of Duchamp's ready-made with
a punk sensibility, she appropriates the
vernacular — objects, expressions, stereo-
types — to re-create existing things in a
parallel world, where underlying givens are
brought sharply into focus. *Bitch* of 1995,
for example, assembles simple materials
with a striking economy of means. Using a
tight white t-shirt stuffed with a pair
of melons, and a vacuum-packed kipper,
she effectively transforms a plain wooden
table into an image of a woman on all
fours. A cliché of male fantasy is instantly
recast as a crude, misogynistic gesture.
The power of Lucas' work hinges not only
on her ability to make such associative
connections, but clearly on the viewer's
receptivity to her visual jokes and their
implications.

 Lucas was born and raised near the
Holloway Road in north London, and her work
draws on the culture of her working-class
background and environment. The artist has
commented that her work is

both what I like and what I'm like. It is
based on my life, not about my childhood
or anything, but what I'm like is so much

fig.61 *Fighting Fire with Fire* 1996, black and white print.
Courtesy Sadie Coles HQ, London

85

Fig.61 Smoking 1998, black and white print. Courtesy Sadie Coles HQ, London

to do with how I grew up and where. And, if you like, that is my point of view, and I try and make things according to my own point of view.[2]

Though more widely shown abroad than in this country, her work has a peculiar relevance to British audiences, as Waldemar Januszczak observes:

You probably have to be British to savour fully Sarah Lucas' sculptures … you need to have sampled pubs and beer, snooker and rain, jellied eels and the tepid, Anglo-Cypriot doner kebab … Above all, you must know what *The Sport* consists of, even if you do not buy it yourself.[3]

Lucas reworks such traditional themes as sex and death with shameless honesty, foregrounding bodily functions and cravings, exploring contradictory feelings of desire and disgust, attraction and repulsion. Like a number of her peers, notably Damien Hirst, Lucas seems obsessed with the theme of smoking, frequently using the cigarette as a 'readymade'. She began smoking as a child:

I had my first drag when I was four. I went into the toilet with my mum at this wedding and she left a cigarette burning on the side of the sink, so I had a quick drag. It was really, really horrible. When I was nine, I taught myself to smoke as a way of getting into local youth clubs and some boys' clubs where you were supposed to be twelve to get in … When I was thirteen I got my first job, which meant I had the money to start smoking completely regularly.[4]

Her work often suggests a tortuous ambivalence towards the pleasures of smoking, which any hardened smoker might share.
In a series of self-portraits, she turns the clichéd fetishisation of the cigarette between a woman's lips into a means of creating 'personal' space, literally a smokescreen between herself and the outside world. In other works, she associates the act of smoking with the creative process. For example, *Chuffing away to Oblivion* (1996), a small, box-like room plastered inside with nicotine-stained tabloid cuttings, suggests a men's smoking room. It was based on the idea of a pub, where drinking and smoking enable Lucas to find her own 'time zone'. She has commented: 'There's something about that whole timeless quality that's essential to making art. To actually get anywhere with it, you have to be prepared to suspend time'.[5]
Yet the darker aspects of smoking as an addictive, potentially lethal habit are suggested in other works, notably, *Where Does it all End* of 1994, a small,

editioned, blood-red wax cast of the lower part of the artist's face. Clenching a cigarette butt in the corner of her her grimacing mouth, she creates a defiant yet hopeless gesture. Smoking, Lucas readily admits, is often something you do when there is little to care about in life:

If you're in the throes of some emotional situation or your life's going wrong in some way, the last thing you really care about is whether you get cancer next week … I suppose women smoking does seem quite aggressive, quite tough. You see a lot more women than men smoking these days, and a lot of working class women. When you see people with a fag dangling from just one lip — sitting in the laundrette or hanging around council estates — it's not so much a 'Fuck you!' thing, so much as you sense there's something hopeless about their life. The idea that it might actually be healthy to give up smoking becomes redundant in such a harsh environment.[6]

A large recent sculpture, *Life's a Drag Organs* (1998), comprises two burnt-out cars, a Ford Sierra and a Buick Sable. Once proudly owned, these charred, wrecked vehicles are decorated with hundreds of unlit Marlboro Reds. Painstakingly arranged on the front seats or bonnets of the cars, the cigarettes are a playful concession towards an audience suspicious of contemporary art, such as the community she grew up in, where art was only recognised as such if it demonstrated dexterity, skill and time-consuming labour. Seen in conjunction with the title of the piece, the distressed cars become hideously tarred lungs, disfigured and contaminated by inhaled smoke. The title implies that smoking is an activity that staves off boredom, yet the conflict between the pleasure of smoking and the knowledge of its effects produces a constant state of tension. Printed on the side of every cigarette packet, these consequences are ever-present.

fig.63 *Life's a Drag Organs* 1998, 2 burnt cars, cigarettes, glue. Collezione Prada

Here, grim humour thinly veils more serious concerns about the subjugation of individuals to oppressive systems that seem to render any resistance futile. It is difficult not to be reminded of the way in which both cigarettes and cars function as lifestyle status symbols. Both represent time and space claimed for ourselves, a means of isolating ourselves from the mass. But these personal freedoms are bought at a price. As cigarettes destroy living tissue and cause death, so cars continue to blight the environment, polluting the atmosphere and inflicting fatalities. Lucas has produced a body of work that, for all its brashness, subtly points to issues that are at once personal and political, individual and social.

1 'A Nod's as Good as a Wink: Sarah Lucas interviewed by Carl Freedman', *Frieze*, issue 17, 1994, p.31.
2 Ibid., p.28.
3 Waldemar Januszczak, 'Maybe it's because she's a Londoner', *The Sunday Times*, 25 May 1997, Art 11.8.
4 Sarah Lucas interviewed by Gregor Muir, *Dazed & Confused*, issue 32, 1997, p.56.
5 Ibid., p.57.
6 Ibid., p.56.

fig.64 *Jimmy Saville Scarecrow* by Jilly and Graham Whitely, Wray, Lancashire, 2000

The artists Jeremy Deller and Alan Kane occasionally collaborate to realise specific projects. Collaboration is in fact central to their individual practices. Both act as catalysts, foregrounding the creativity, enthusiasms and interests of others, in an attempt, not to invalidate high culture, but to highlight and reveal what might be meaningful in a society saturated with off-the-peg identities and lifestyles. What at first might appear to be a form of detached social anthropology, is more accurately described as a 'celebration of subjectivity'. Their work stems from a desire to investigate and draw attention to whatever genuinely moves, motivates or gives meaning to people's lives.

Deller has successfully raised questions about value in our culture through a series of works comprising incongruous juxtapositions, which in usual circumstances might constitute a culture clash — debutantes meeting a football 'firm'; pensioners recording songs on state-of-the-art equipment; a series of *Middle Class Hand Signals*, presented as if they were the gestures of US gangs. A typically low-key approach to collaboration enables him to bring together unexpected and potentially awkward elements, which develop a life

of their own. His best-known work, *Acid Brass* (1996), comprised a medley of acid house anthems, which were then transcribed by arranger/conductor Rodney Newton and played by the Williams-Fairey Band at Liverpool School of Performing Arts, and the Queen Elizabeth Hall in London. Having instigated the idea, Deller was happy to see the band take the project forward, so that when eventually an Acid Brass CD was released, its origins as an art project seemed unimportant.

Acid Brass grew out of Deller's belief that acid house and the miners' strike were the defining moments in British history during the 1980s. Deller found interesting connections between the world of brass bands and that of rave music, which he mapped out diagrammatically in *The History of the World* (1996). Acid house inspired the summers of love at the end of the 1980s, which can be seen retrospectively as a counter-cultural movement that rallied disaffected British youth against the demoralisation of the Thatcher years. Northern brass bands continue to define local communities long after the decline of the mining industry around which they were originally built. Both acid house and brass bands stand for community, and are forms of resistance to prevailing conditions.

Many of Deller's projects could be deemed patronising, manifestations of a middle-class fascination with 'kitsch'. Will Bradley notes:

> Like a lot of what Deller does, *Acid Brass* walks a fine line, stepping up almost to the brink of mockery. But it's that element of the absurd, the bizarre sincerity of it all that draws you in, requires that you believe a little and not just consume, and gives the work its edge.[1]

In 1997 Deller invited fans of the pop group Manic Street Preachers to pay tribute to their idols in his exhibition *The Uses of Literacy*. These contributions mostly

fig.65 Girls Fancy Dress Day Out, Blackpool, March 2000

took the form of drawings, which he displayed in a gallery along with books and interviews with fans recorded for Deller by Audio Arts (see p.92). The title of the piece refers to Richard Hoggart's book of 1957, an assessment of what might constitute value in our language and literature and what, conversely, might lead to cultural decay. In Deller's *The Uses of Literacy*, teenage obsessions with pop groups, often dismissed as trivial and indulgent, are revealed as forms that enable young people to engage with culture on their own terms. As Michael Archer has pointed out:

> Deller's unwillingness to assert himself over the fans leaves room for them to reveal how, through the inspiration to

fig.66 The Maypole, Padstow, Cornwall, 1 May 2000

read and think offered by the group's music and lyrics, they are searching for and beginning to find their own voice.[2]

Deller has talked of fans as 'moral share-holders' of a band, the guardians of its integrity in the face of commercial success and compromise. Through adoration and obsession, the fans help to create the band, giving meaning and purpose to the music. The artist seems attracted to such areas of apparent superficiality, revealing the real worth with which they have been invested by people, and the ways in which they can motivate and structure lives.

Alan Kane has developed a series of walking tours, in the first instance conducted by himself, which question the relative value of our experiences. The most recent of these projects, for The New Art Gallery

in Walsall, took the form of a leaflet describing tours for people to undertake themselves. These included 'The Wilful Misinterpretation of Information', designed to stimulate thinking about the latent potential of signs and information in the immediate environment. Kane informs the intrepid walker that

> Historical, geographic and psychological features are at our disposal for rede-ployment as games pieces … The world may not be our oyster but everything in it may be a pearl we cultivate for our-selves.[3]

Another tour, 'Continue From The Perspective of Someone Else', invites the audience to wear a disguise when taking a journey or performing a task:

Attempt to recognise modifications in your environment or the reaction you receive due to the disguise, as well as modifications to your attitude and behaviour. Consider the factors at work in this experiment and re-evaluate all of your relationships to people and places based on these factors.[4]

Kane appears to grapple with the difficulty of authorship. As an artist, he is expected to have 'something to say', to be influential, to contribute to culture. His art practice attempts to deal with the inherent contradiction in wanting both to influence and to empower, without falling into the trap of being as prescriptive and imposing as the worldviews he tries to counter.

An introduction to Folk archive (2000), shown in this exhibition, documents the beginnings of the ongoing collaborative project, *Folk archive*. Initiated by Deller and Kane in 1999, the project developed out of their interest in authentic forms of cultural activity and self expression — authentic in the sense that these activities help to define individuals and communities, resisting the homogenising and deadening effects of mass consumer culture manufactured by global capitalism. Folk art evolved to mark such key moments or rites of passage as births, marriages or deaths. Made by skilled amateurs, it represents a relatively autonomous tradition of craftsmanship. Methods and designs, to a large extent impervious to fashion and changing taste, are handed down within the home or local community. Though sometimes influenced by professional 'high' art, folk art tends to retain its own character and techniques.

Concerned that certain grass-roots activities were in danger of being eclipsed by the ubiquity of a dominant consumer culture, the artists set out to document exemplars of contemporary folk art before they became extinct. They soon became aware that folk art is flourishing and adapting. *An introduction to Folk archive* focuses on the artists' involvement in the project so far, and includes some examples of their findings during a year-long search across Britain. Although *Folk archive* should not be considered in any way an authoritative or comprehensive survey, it nevertheless comprises a surprising and eclectic range of cultural artefacts and practices, from meticulously crafted objects sold at Women's Institute bazaars, to an elaborate hobby horse, and performative, even ritualistic practices such as gurning and tatooing. The artists' ongoing research aims to record and celebrate examples of making, of creativity and problem-solving:

We aim to highlight and preserve some of the undervalued cultural production of individuals in the face of the increasingly aggressive consumer society we inhabit, and investigate how this production may be adapting to a rapidly changing world.[4]

1 Will Bradley, 'The Uses of Literacy' *Afterall*, pilot issue, 1998/99, p.10.
2 Michael Archer, *Voice Over: Sound and Vision in Current Art*, South Bank National Touring Exhibitions catalogue, p.13.
3 Alan Kane, *Walsall For Adventurers: Several Walking Tours Of This Borough*, leaflet, The New Art Gallery, Walsall, [undated].
4 Jeremy Deller and Alan Kane, statement to the author, 1999.

Sound is a primary medium; in listening to the recorded voice we hear what was (and inserted into our real time, still is) the thing itself, manifest, absolute, poignant. We are touched by it; it enters us by way of a physical sense.[1]

William Furlong is primarily a sound artist. He has been the editor and driving force behind the tape magazine *Audio Arts* since its inception in 1973. The project began as a response to the comparatively new medium of cassette tape and has developed over the past twenty-seven years into an extraordinary archive of artists, curators, writers and others speaking directly and off-the-cuff about the issues and projects of the day. Beginning as an artist-run audio magazine, by the 1980s Audio Arts had become an art project in its own right, informed by Furlong's deep understanding of the medium of conversation as an artistic material like any other. Speech, unlike the printed word, contains a trace of the moment of its utterance and the nuances of accent, intonation and phrasing with which so much can be expressed. The recordings Furlong has made over his career tell us particular things about their subjects, they speak of hesitation or magical fluency, language barriers and Freudian slips, all the marks of language as it is used in the world rather than on the record.

Furlong's editorial decisions, while often barely noticeable, are chiefly responsible for the coherence of both Audio Arts and his independent work. It is where

figs.67,68 Gathering recorded material for *Spoken For/Spoken About* (*Voiceover*, Llandudno) 1998. Courtesy the artist

the exercise of his creative intelligence functions as both a gatherer of information and a processor of that information in a way that aids intelligibility. His identity as an artist also provides him with a keen sense of responsibility towards his subjects and he is careful to attempt to stay true to the spirit of the original utterances. Significantly, he always edits directly from the audio source, avoiding any paper transcriptions and thereby staying closer to the sound and timbre of the voice. The recordings are therefore not simply interested in expressing a singular point of view (the artist's or the speaker's) but in the variegated, contradictory nature of human discourse — contradictions that occur as much within a single individual's statements as between two interlocutors. In these terms, his work with Audio Arts can be said to be located somewhere between the definitions of artist, curator and editor without ever settling on a single mode of operation.

Independently of Audio Arts, Furlong also produces work that makes use of the skills he has built up with the magazine but are identified as solely his own work. Recently, this aspect of his production has come more to the forefront with major pieces at the Serpentine Gallery, London, the Imperial War Museum, London, the Goodwood Sculpture Park, and in the touring exhibition *Voice Over*. The Serpentine is perhaps closest in spirit to the work for *Intelligence*, in that it edits together a number of independent interviews to produce a work consisting of disparate voices in conversation called *Sound Garden* (1998). The work was sited outside the Serpentine building on a small lawn into which a number of audio speakers were buried beneath grilles placed at ground level and almost lost in the grass. The conversations were brought together from recordings made with casual passers-by in the weeks preceding the opening. They spoke of their subjective experience of the park and their reasons for using it, either at that moment or in

fig.69 *Walls of Sound* 1998, stainless steel. Enabled by and sited at Sculpture at Goodwood

more general terms. The whole work created a feedback loop, magnifying the atmosphere of the city park and relaying the subjective impressions of a diverse group of individuals. It highlighted the park as a multi-layered place in which people look for sanctuary, society or the opportunity for casual drifting.

These recent works have also begun to develop a confident sculptural language through which the conversations are orchestrated for the viewer. In *Intelligence*, this aspect is articulated through a series of simple cube seats, under each of which a speaker transmits a part of the work. The sound is edited from a series of interviews that Furlong has carried out with each of the selected artists, bringing the voices of the individuals who have made the exhibition into the gallery. The work is sited

fig.70 *Sound Garden*, Serpentine Gallery, London 1998 (detail) Courtesy the artist

at the end of the show, as the last room where visitors can take the opportunity to think about the totality of *Intelligence* and listen to a variety of responses and opinions about the exhibition's title, the work, and the state of art in Great Britain. The work entitled *Thosel*, an Irish word of Anglo-Saxon origin that refers to the place in a village where people gathered to exchange ideas and discuss issues. The attempt here is to emphasise the potential of dialogue, not only between the artists, but also with and between the viewers of the exhibition. The encouragement of this dialogue and the idea that contemporary art in these islands is a contested field that can impact on all its citizens in different ways is fundamental to both the exhibition and to Furlong's ideas as an artist. Art is, in these terms, part of the living continuum of what the philosopher Michael Oakeshott called 'the conversation of mankind'.[2]

1 Mel Gooding in *William Furlong, Audio Arts, discourses and practices in contemporary art*, London 1994, p.6.
2 Ibid.

JULIAN OPIE Plan for exhibition 2000

MARK LEWIS Still from *The Pitch* 1998, 35mm film.
Courtesy Patrick Painter Editions, Vancouver

DOUGLAS GORDON *List of Names* 1990 installed at Kunstverein Hannover 1998.
Courtesy the artist and Lisson Gallery, London

SUSAN HILLER *Witness* 2000, mixed media sound installation.
Installed at The Chapel, 92 Golborne Road, London W10. Commissioned by Artangel, London.
Courtesy the artist

TACITA DEAN Still from *Bubble House* 1999, 16mm colour film.
Courtesy the artist and Frith Street Gallery, London

GRAHAM GUSSIN Still from *Spill* 1999, 16mm black and white film. Artist's collection

MARTIN CREED *Work No.232: the whole world + the work = the whole world* 2000,
white neon. Installation at Tate Britain, London, 2000 (left);
Work No.230: DON'T WORRY 2000, white neon. Courtesy the artist and Cabinet, London

BOB AND ROBERTA SMITH *STOP IT WRITE NOW!* 1999.
Two views of installation originally commissioned by Beaconsfield for *British Links* at the
National Museum of Contemporary Art, Oslo 1999

LIAM GILLICK *Consultation Filter* 2000, anodised aluminium, plywood and Formica.
Commissioned by the Westfälischer, Kunstverein, Münster. Courtesy the artist and Corvi-Mora

BRIGHID LOWE *I Saw Two Englands Breakaway* 1996–7, 225 books, 450 Perspex mounts,
C-type on flexibase. Detail of installation at John Hansard Gallery, Southampton 1997. Courtesy
the artist

RICHARD WRIGHT Work from Inverleith House, Edinburgh 1999, gouache with gold leaf
(left); gouache (right). Courtesy the artist/The Modern Institute, Glasgow

ALAN JOHNSTON *Wall Drawing* 2000, pencil, site-specific installation at Pekao
Gallery, Toronto (detail, left); *Wall Drawing* 1999, pencil, site-specific installation at Iselin
Haus, Riehen, Basel

HILARY LLOYD Stills from *Landscape* 1999, video. Courtesy the artist

JAKI IRVINE Stills from *Eyelashes* 1996, 8mm film.
Courtesy the artist and Frith Street Gallery, London

OLADÉLÉ AJIBOYÉ BAMGBOYÉ Stills from *Spells for Beginners* 1994/2000,
living room environment and video installation. Courtesy the artist

YINKA SHONIBARE *Vacation* 2000, wax-printed cotton textile, fibreglass (details).
Courtesy the artist and Stephen Friedman Gallery, London

MICHAEL CRAIG-MARTIN Working drawing for *Store Room* 2000,
computer-generated image. Courtesy the artist and Waddington Galleries

GILLIAN WEARING Stills from *Drunk* 1999, video (left); *Prelude* 2000, video.
Maureen Paley / Interim Art

SARAH LUCAS *Life's a Drag Organs* 1998, 2 burnt cars, cigarettes, glue.
Collezione Prada

JEREMY DELLER AND ALAN KANE Selected images from
An introduction to Folk archive 2000

WILLIAM FURLONG Extracts from *Tholsel* 2000 (left); the artist interviewing
Martin Creed (top right) and Oladélé Bamgboyé for *Tholsel* 2000

MARK LEWIS

JAN STEVENS
ANDREA McINDEWAR
IAIN CHRISTIE
FIONA GRIFFITH
DIETMAR ELGER
NUNO ALMEIDA
LUKE BENNET
THOMAS GLATTER
COCO KAY
THOMAS KRENS
JULIA BOLZ
THOMAS CARELL
MAURICE O'CONNELL
FRANK HYDE-ANTWI
DAVID RANKIN
SIMON EISINGER
PAUL KURANKO
LISA BILLARD
NUSCH SCHULBAUM
ANNIKA STRÖM
JUTTA EBERHARD
GUNTHER BECKER
MARGARET ARCHBOLD
ANDRE MAGALHAES
NICOLA ATKINSON GRIFFITH
ANDREW GILCHRIST
JONATHAN CALLAN
JOÃO FERNANDES
JOCK BRECKENRIDGE
COLLIER SCHORR
JOYCE PATERSON
AUDREY SMILLIE
TIM MAGUIRE
BERNHARD PRINZ
ALYSSIA FRAMIS
HEATHER ROGERS
NORMAN ROSENTHAL
CHRISTINE VAN ASSCHE
HAYLEY TOMPKINS
TEMBA MINTJES
REBECCA WARREN
ZOE WALKER
EDWARD LAVERTY
THOMAS SCHUTTE
GEERT SCHRIEVER
OLIVE WILSON
GARY SCOFIELD
CAROLINE WOODLEY
DAVID ELLIOT
GABRIELE SAND
KETIL NERGAARD
HEIKE HELFERT
GREGOR SCHNEIDER
EMILY BATES
ISABELLA HEUDORFF
BRIGITTE RAABE
IAIN McFADDEN
LIZA MAY POST
PAUL CHRISTIE
JOSEPH CAMPBELL

DENNIS VERMEULEN
FRANCESCO SIMETI
ANGELINE SCHERF
OLIVIER SCHULBAUM
CARL-JOHANN VALGREN
ELA STRICKERT
RAINER KLEEMANN
JAN DEBBAUT
ERIC DUYCKAERTS
MICHAEL CLARK
MAX WIGRAM
ELENA FERNANDES
MYRTLE BRECKENRIDGE
BICE CURIGER
JILL HAIG
EDUARDO PAOLOZZI
WENDY JACOB
PIERRE LEGUILLON
ADAM SQUIRES
SARAT MAHARAJ
OLAFUR ELIASSON
HARALD FRICKE
SIOBHAN LIDDELL
AMI BARAK
BERNHARD STARKMANN
TIM NIEL
EULALIA VALLDOSERA
JILL SILVERMAN
FRITZ SCHWEGLER
KARIN SANDER
DANIEL BUREN
AYSE ERKMEN
IAIN PIERCE
JEAN LUC PEERS
CHRISTINE HILL
SASKIA BOS
ERIC GONGRICH
JES BRINCH
MICHAEL FOOT
RAYMOND BELLOUR
LAURA SARMENTO
CHERIE BLAIR
DIRK SNAUWAERT
HUBERT NEUERBERG
LORNA SIMPSON
MARTINE BOHNE
MIRTHA CODOGNATO
ANNA HANSEN
RAIMAR STANGE
INGEBORG LUSCHER
ROMAN MENSING
BRIGITTE CORNAND
MARTIN GOSTNER
PIERRE HUYGHE
JEREMY DELLER
RUBEN ORTES-TORRES
SHANNON SHAPIRO
BARBARA STAVINI
EVA SCHMIDT
JEAN MARC BUSTAMANTE

RICHARD DOWNES
CHRISTINE HOHENBÜCHLER
LOTHAR HEMPEL
ELLA KLASCHKA
DENNIS HOPPER
DAVID TREMLETT
MARTHA McCULLOUGH
TOM THOMPSON
ROBIN KLASSNIK
CHRIS WALLACE
RONALD SCHWARTZ
MICHAEL COHEN
FIONA BRADLEY
BARBARA ENGELBACH
NICOLAS ASTI
KIM ADAMS
STEPHEN CRAIG
ISA GENZKEN
ANNIE GRIFFIN
GAVIN TURK
MEK MAAß
JENS HAANING
MONICA SCHWITTE
BARTOMEU MARI
ANDREW DAVIES
MARK VERNON
NICHOLAS FLOCH
MARTIJN SANDERS
DOMINIC HISLOP
INGVILD GOETZ
ANDY AVINI
DIETLIND HOFFMANN
REVILLE WAKEFIELD
PHILIP LACHENMANN
MARIANNE WALTHER
CHRISTOPH GIRARDET
NEIL BEGGS
KRISTINA TIEKE
PHILIP DODD
LOUISE NERI
MARGARET BARRON
SELMA KLEIN ESSINK
CATHERINE OPIE
ADELINE PUTTMANN
GEORG HEROLD
BRIAN PETTIT
THEO WAJON
MARIA LIND
HENRIK HÅKANSSON
CHRISTIAN MARCLAY
LOUISE HOPKINS
IAIN BELL
BILL ENGLISH
DAVID PETERS
GEORGE SPENCE
ELAINE McKAY
NUNO ALMEIDA
STEPHAN GOETZ
JOHN McGROARTY
CLAUDIA BÜTTNER

YUTAKA SONE
GISELA SEITZ
LUDWIG PELTZER
JOEP VAN LIESHOUT
ALEX RENNIE
DAVID POWELL
PETER LAND
RENEE KOOL
LOTHAR BAUMGARTEN
JEAN BAPTISTE BRUANT
ROB VAN DE VEN
COLIN STEVENSON
MARIUS BABIAS
HELEN VAN DER MAY
CHRIS DERCON
MARITE BLOEMHEUVEL
TACITA DEAN
JOHN GILMOUR
CAROLINE ANGUS
BETTINA FUNCKE
ALYSON BAKER
DOMENIQUE GONZALEZ FOERSTER
ALEXANDER MARIS
ALAN JERMIESON
AILEEN McGLAUGHLIN
GAEL McDOUGALL
SIMON CHAMBERS
LINDA KILLIN
KATE MOODY
JOHN CLARK
GERRY GLEASON
UTE IHLENFELD
MARLENE BOYLE
DAVID PRATT
STUART BAXTER
JAN GRAY
ELAINE THOMAS
JOHN McCROSSAN
TOM RANNELL
PAUL NEAGU
ALEXANDER JOHNSTON
CHRISTIAN PHILIP MÜLLER
NEDKO SOLAKOV
ANDREW SCOTT
FRANCIS ALLEN
KATE MORRISON
LORNA ALLEN
ANGELIKA NOLLERT
REGINA BINDER
DONALD CAMERON
RICHARD LEAROYD.
PAUL DIGNAN
SUSAN WAXMAN
RICHARD CORK
MARC OVERMARS
CHRISSIE ISLES
CORINNE GROOT
PAUL ANDRESSE
KEN HAY
EMMANUEL PERROTIN

MARK DION
ROBIN DAW
PETER MOLLER
JACK FARRELL
JANET CARDIFF
GERTRUD SANDQVIST
ADRIAN FOGARTY
JAKOB FABRICIUS
NICK DEVLIN
LINDA GRAHAM
MARY CAMERON
SUTAPA BISWAS
GRAEME PATERSON
DAMIEN DUFFY
BRIAN McEWAN
PETER SUMSION
STEVEN SNODDY
KATE HENDERSON
RON BOWEN
KAREN MURRAY
TRACY CAMPBELL
JOHN SHANKIE
OLIVIA UTRERA
PAULINE RALSTON
IAIN BEVERIDGE
GEORGE McKINTOSH
ALISON KENNEDY
CHRISTINA MACKIE
CLIO LLOYD-JACOB
ANDREW QUEST
WILLIAM CLARK
ANNE COX
GRAHAM BROWN
MICK McLEAN
DREW McALLISTER
JIM McNAUGHT
SANDY STODDART
KENNY MEECHO
FLORENCE KANE
BRYAN FERRY
WILLIAM FURLONG
SARAH LUCAS
ANNA PANK
LUC STEELS
JEM LEIGH
ANYA GALLACCIO
CLIFF BOWEN
ADRIAN O'DONNELL
TESSA JACKSON
JULIE HANNAH
TOM McKENDRICK
MARTIN TIERNEY
DOUGLAS McINDOE
ALAN McLEAN
NOAM CHOMSKY
KEN GILL
PATTY KNOX
MARY McMENEMY
ALEX CRUIKSHANKS
JURGEN BORCHERS

DOUGLAS GORDON

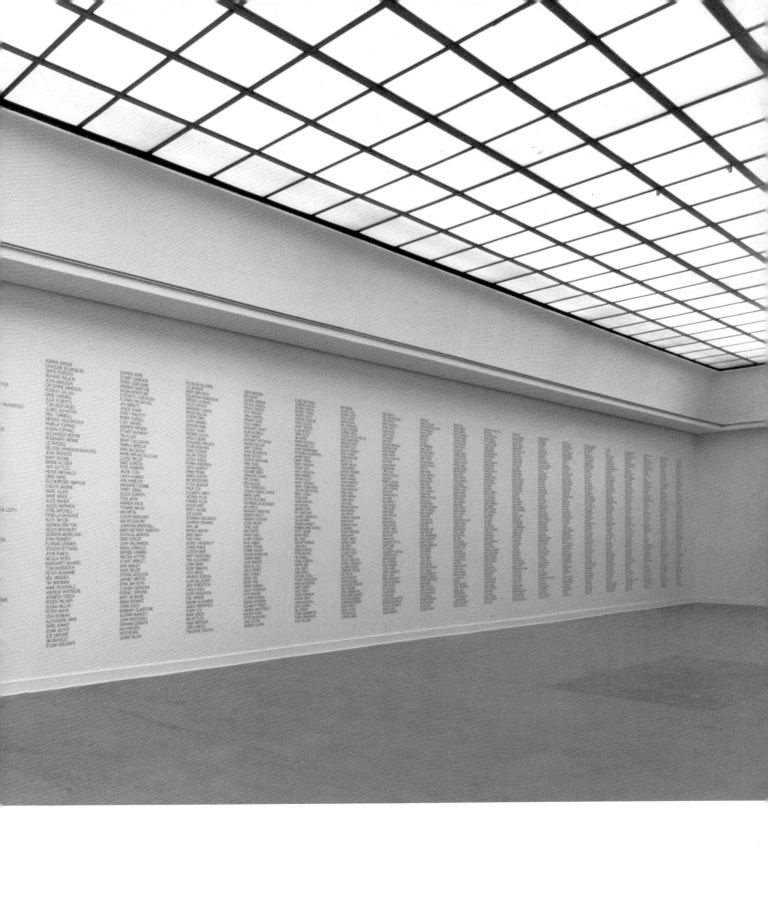

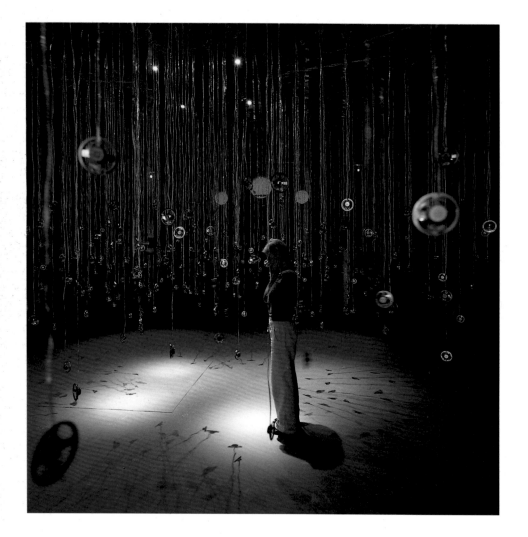

SUSAN HILLER

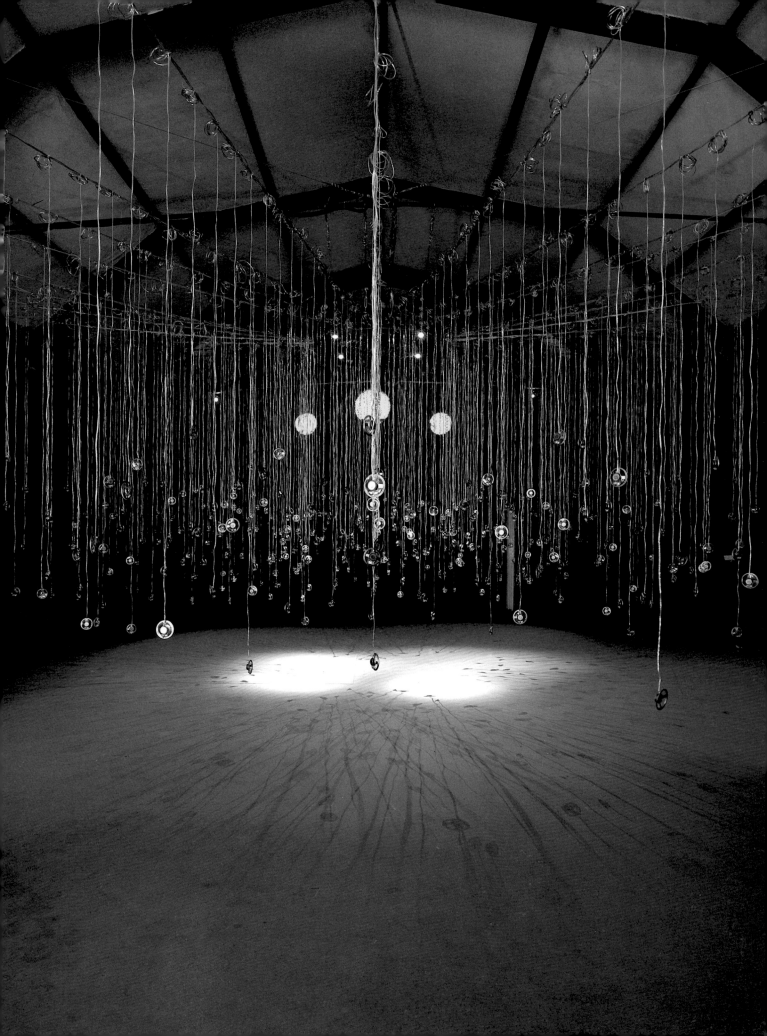

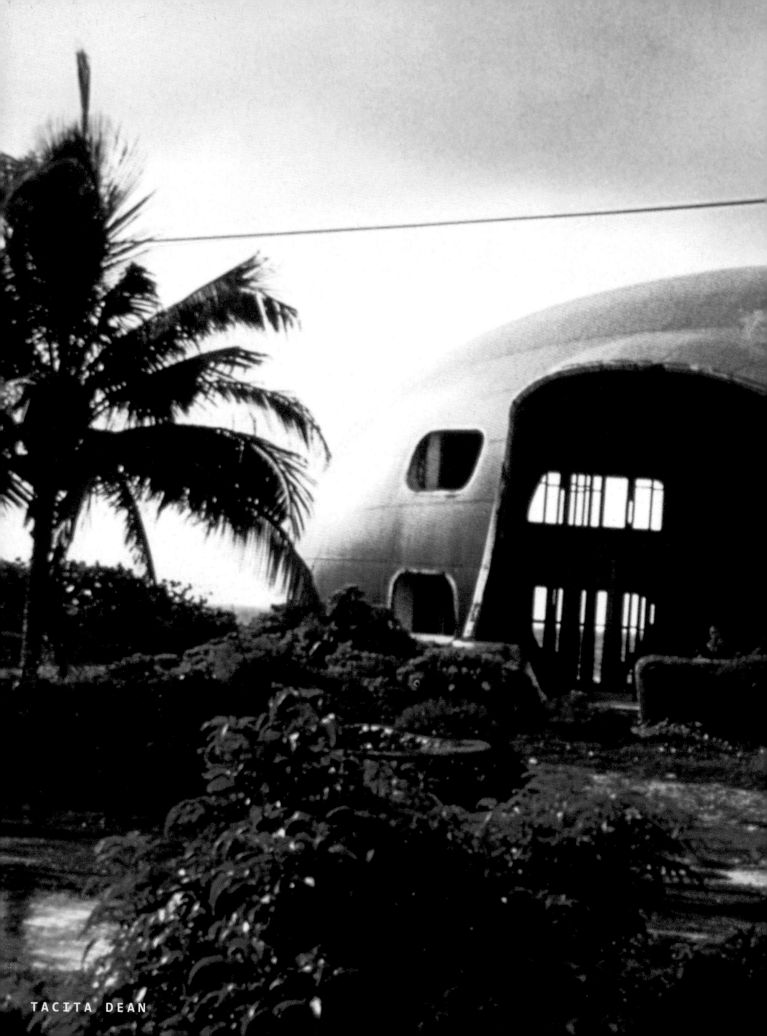

TACITA DEAN

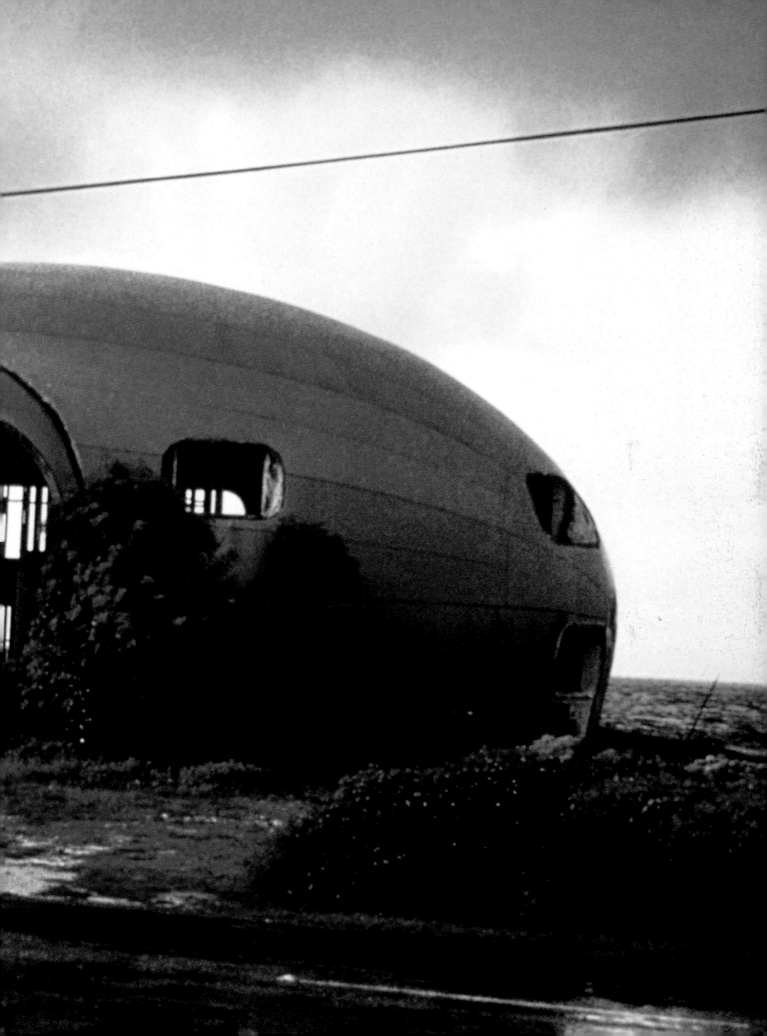

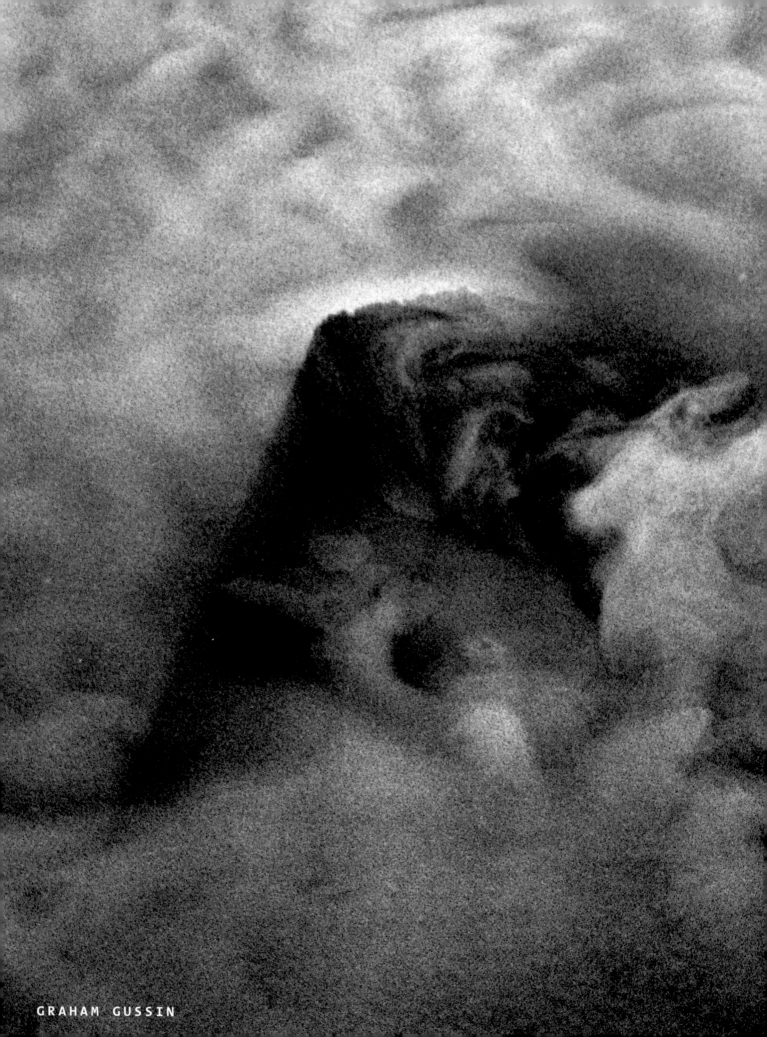

GRAHAM GUSSIN

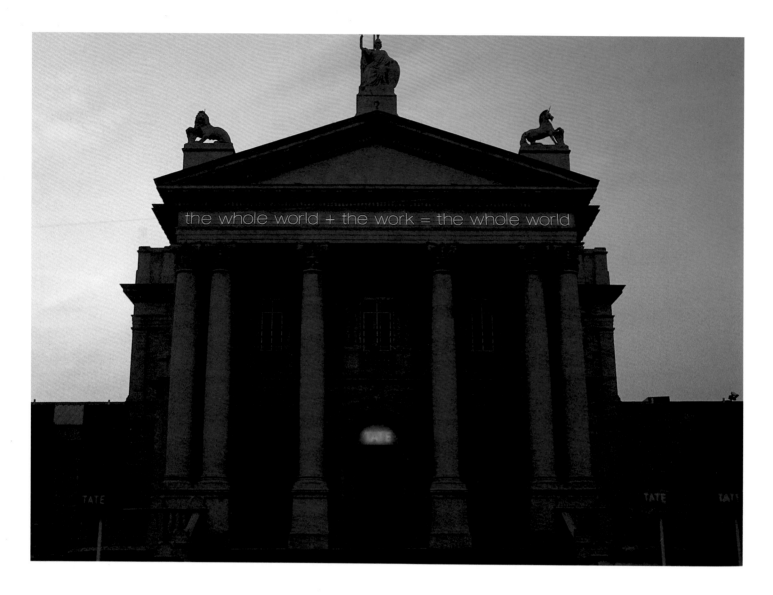

MARTIN CREED

BOB AND ROBERTA SMITH

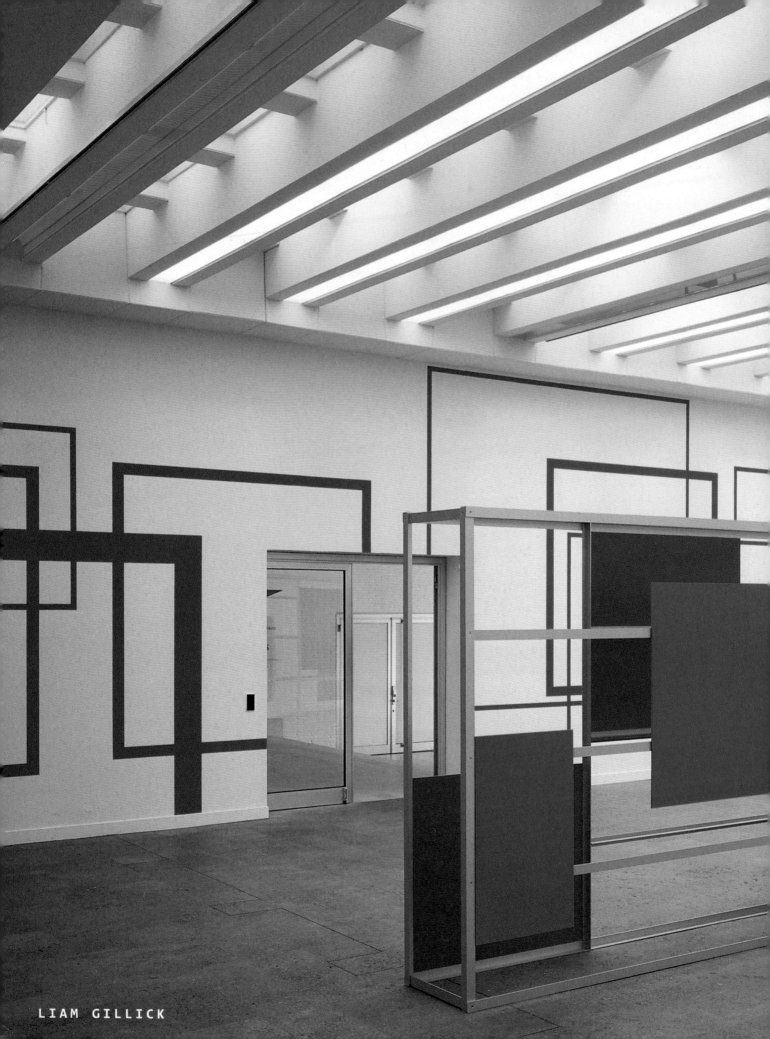

LIAM GILLICK

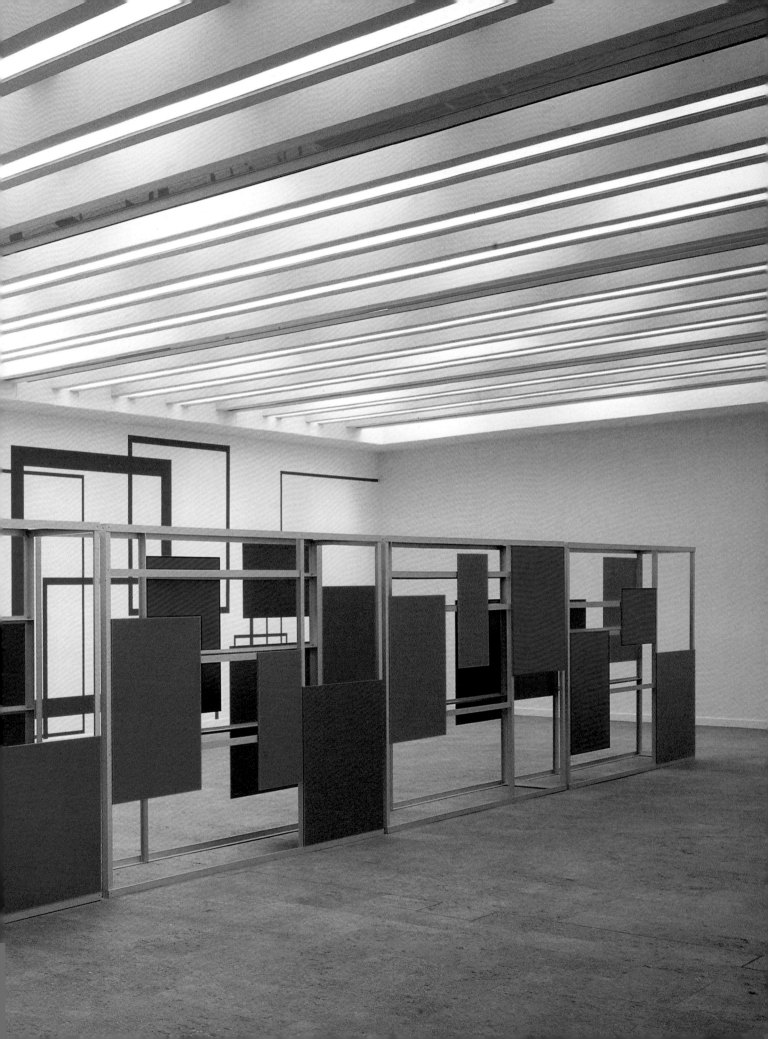

RICHARD WRIGHT

ALAN JOHNSTON

JAKI IRVINE

OLADÉLÉ AJIBOYÉ BAMGBOYÉ

YINKA SHONIBARE

MICHAEL CRAIG-MARTIN

GILLIAN WEARING

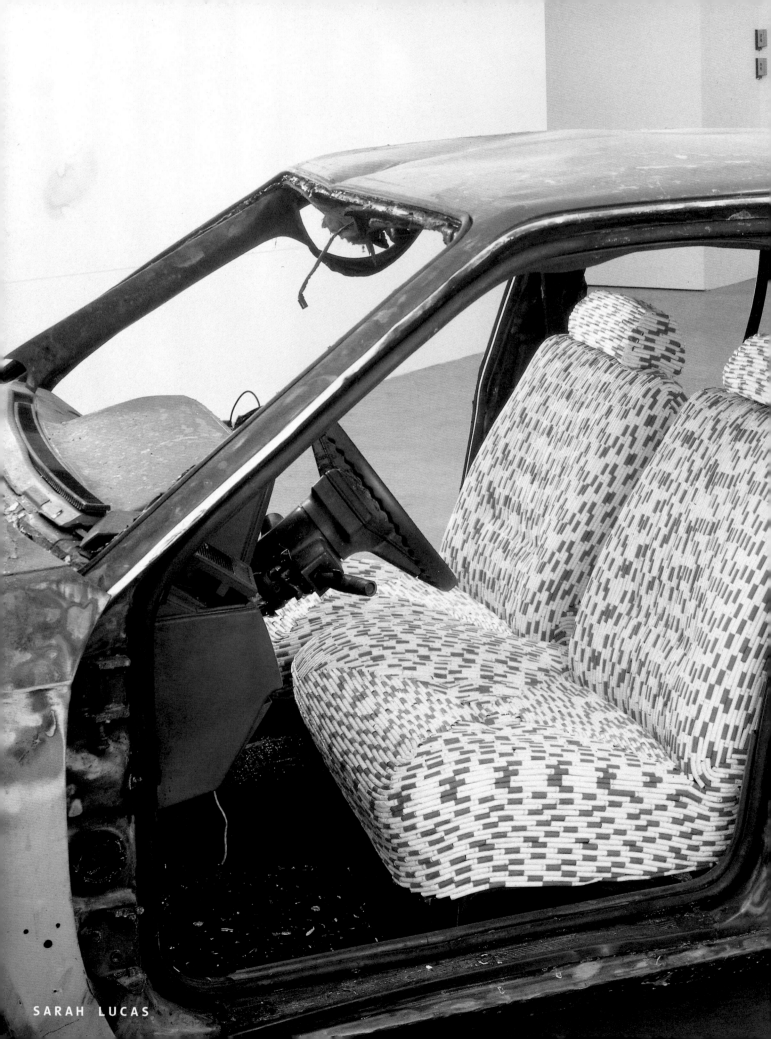

SARAH LUCAS

What is the most important question for you as an artist to address? … I want to make things because of other people … some of the works are made for a room, but it could be any room … I think it's all about problems … It would be nice if people didn't worry in art galleries … **I'm asking all the artists in the exhibition the same set of questions** … I suppose the question of why one makes art in the first place … items of culture which have been discarded or dismissed as being really silly or trivial or even embarrassing … I've always been interested in borderline areas … the activities one is involved in can find their home within art … in using that term to approach work, is to start with some theory that is already a cultural artefact … I'm seeking the unknown … **can you talk a litle more about the underlying concerns of your work?** … I tend to work with things that I hate a lot and like a lot at the same time … maybe its rather institutionalised conceptual art practice, following on from Duchamp … that's what my work is about, very modest investigations … the things of ordinary life … **to what extent is your work speculative? If so describe how** … I'm attracted to things that I'm simultaneously repulsed by … to look more closely at things … looking at artefacts that I feel ambivalent towards … the way that the visual merges with the visionary, could be the actual key … it's reality of a different order … ideas about exploration, colonisation, colonial space … anything that's yellow could be blue … get the Women's Institute to take over the ICA for six weeks and do the programming, catering, talks, everything … a route is suggested or created for the person within the gallery space … artefacts that swim in the unconscious of our culture … **describe the physical experience of your work in this exhibition** … it's quite a malignant-looking substance … it started with a conversation … but it's not at the surface, it's a powerhouse … it's part of your life, it runs with your life, it's inspired by your life … my own personal history … it's time-based work … **it also seems to me to be an interrogation of ideas** … is it possible for film to be art? … for me it's all a blur. I can't separate the things that I make from the rest of the world … Whatever happens, happens over a long period … because of the very thin line between the visual and the visionary … I want them to be situated where I'm situated, which is on this paradoxical borderline … and they are often people I meet once and never meet again … it was shockingly, kind of shockingly painterly … I like the idea that when we look at something, there is a kind of meeting point that is proposed … **in a way, the notion of site specific not only embodies ideas about a physical space and its resonance but also the issue of time** … on the other hand people wilfully destroy themselves … at college I sort of poopoo'd craft … it's all about a kind of dissent really … you could actually do a drawing in the sand if necessary … working in the area between moving image and sound … other people's definitions of consistency, I don't fit that … it deals with accents … **is there a specific impulse that runs through all of your work?** … I don't want to be on the outside looking in … I like travelling to find new things … the structures of language and things like that … the sea because it is indefinable … God, what a waste of cigarettes, it's nothing like the waste of smoking them … there's a lot of talk about revised institutional critiques … **what is the criteria for selection and mediation?** … trying to establish a sort of flickering … I've chosen a group of people, that is a group within society … the impossibility of finding a plausible answer is more interesting than finding the answer … not wishing to identify art according to the means by which it was made … if you loose the keys to your house, you don't do nothing, you look for them … the things of ordinary life … and I gradually recovered …

WILLIAM FURLONG

LIST OF EXHIBITED WORKS

in alphabetical order

OLADÉLÉ AJIBOYÉ BAMGBOYÉ

Spells for Beginners
1994/2000
Living room environment,
Betacam SP Pal video tape,
5 minutes with audio,
transferred to DVD
Dimensions variable
Courtesy the artist

MICHAEL CRAIG-MARTIN

Store Room 2000
Site-specific installation,
Tate Britain
Courtesy the artist and
Waddington Galleries

MARTIN CREED

Work No.220: DON'T WORRY 2000
White neon 25 × 183 cm
Edition 3/3
Courtesy the artist and
Cabinet, London

*Work No.74: as many 1″squares
as are necessary cut from 1″
masking tape and piled up,
adhesive sides down, to form
a 1″ cubic stack* 1992
Masking tape, polystyrene,
paper, cardboard
Edition of 100
Courtesy the artist and
Cabinet, London

TACITA DEAN

Bubble House 1999
16mm colour film
Courtesy the artist and Frith
Street Gallery, London

JEREMY DELLER AND ALAN KANE

*An introduction to Folk
archive* 2000
Mixed media
Dimensions variable
Courtesy all the artists

WILLIAM FURLONG

Tholsel 2000
Sound installation
Dimensions variable
Courtesy the artist

LIAM GILLICK

Applied Distribution Rig 2000
Aluminium, Formica
240 × 600 × 700 cm
Courtesy the artist and
Corvi-Mora

DOUGLAS GORDON

List of Names (since 1990)
Text installation
Dimensions variable
Courtesy the artist and
Lisson Gallery, London

GRAHAM GUSSIN

Spill 1999
16mm black and white film
Artist's collection

SUSAN HILLER

Witness 2000
Mixed media sound installation
Dimensions variable
Courtesy the artist
Commissioned by Artangel,
London

JAKI IRVINE

Eyelashes 1996
8mm film transferred to video
Courtesy the artist and
Frith Street Gallery, London

ALAN JOHNSTON

Wall Drawing 2000
Pencil
Site-specific installation,
Tate Britain
Courtesy the artist and
Jack Tilton Gallery, New York

Wall Drawing 2000
Pencil
Site-specific installation,
Tate Britain
Courtesy the artist and
Jack Tilton Gallery, New York

Untitled 2000
Pencil, charcoal, titanium
white, beeswax, MDF
37 × 34 × 4 cm
Courtesy the artist and
Jack Tilton Gallery, New York

Untitled 2000
Pencil, charcoal, titanium
white, beeswax, MDF
37 × 34 × 4 cm
Courtesy the artist and
Jack Tilton Gallery, New York

Untitled 2000
Pencil, charcoal, titanium
white, beeswax, MDF
37 × 34 × 4 cm
Courtesy the artist and
Jack Tilton Gallery, New York

Untitled 2000
Pencil, charcoal, titanium
white, beeswax, MDF
37 × 34 × 4 cm
Courtesy the artist and
Jack Tilton Gallery, New York

Untitled 2000
Pencil, charcoal, titanium
white, beeswax, MDF
37 × 34 × 4cm
Courtesy the artist and
Jack Tilton Gallery, New York

Untitled 2000
Pencil, charcoal, titanium
white, beeswax, MDF
37 × 34 × 4 cm
Courtesy the artist and
Jack Tilton Gallery, New York

MARK LEWIS

The Pitch 1998
35mm, colour, 4 minutes
(looped) transferred to DVD.
Shown on a monitor
Courtesy Patrick Painter
Editions, Vancouver

HILARY LLOYD

Monika 2000
Sony PVM-20N5E video monitor,
Pioneer V7300D DVD player,
Unicol single-column stands
Dimensions variable
Courtesy the artist

Darren and Darren 2000
Sony PVM-20N5E video monitor,
Pioneer V7300D DVD player,
Unicol single-column stands
Dimensions variable
Courtesy the artist

Sotiris 2000
Sony PVM-20N5E video monitor,
Pioneer V7300D DVD player,
Unicol single-column stands
Dimensions variable
Courtesy the artist

City Film 2000
Sony PVM-20N5E video monitor,
Pioneer V7300D DVD player,
Unicol single-column stands
Dimensions variable
Courtesy the artist

BRIGHID LOWE

I Saw Two Englands Breakaway
1996–7
225 books, 450 Perspex mounts,
C-type on flexibase
Books: 193 × 335 × 6 cm;
C-type: 185 × 335 cm
Courtesy the artist

SARAH LUCAS

Life's a Drag Organs 1998
2 burnt cars, cigarettes, glue
146 × 460 × 180 cm;
146 × 473 × 180 cm
Collezione Prada

JULIAN OPIE

A walk in the park 2000
Vinyl
274 × 365 cm
Courtesy the artist and
Lisson Gallery, London

Still life? 2000
Vinyl
217 × 390 cm
Courtesy the artist and
Lisson Gallery, London

Christian, artist 1999
Vinyl
192 × 163 cm
Courtesy the artist and
Lisson Gallery, London

Virginia, housewife 2000
Vinyl
345 × 295 cm
Courtesy the artist and
Lisson Gallery, London

Bathers? 2000
Vinyl
293 × 297 cm
Courtesy the artist and
Lisson Gallery, London

Male nude, reclining? 2000
Vinyl
145 × 416 cm
Courtesy the artist and
Lisson Gallery, London

Barbara t-shirt skirt 2000
Vinyl and paint on aluminium
185 × 56.2 × 15 cm
Courtesy the artist and
Lisson Gallery, London

Carl t-shirt jeans belt 2000
Vinyl and paint on aluminium
193.6 × 67.1 × 15 cm
Courtesy the artist and
Lisson Gallery, London

Fabrice shirt t-shirt jeans
2000
Vinyl and paint on aluminium
181 × 61.8 × 15 cm
Courtesy the artist and
Lisson Gallery, London

Amanda jumper skirt boots 2000
Vinyl and paint on aluminium
187.5 × 54.8 × 15 cm
Courtesy the artist and
Lisson Gallery, London

Tessa anorak trousers arm-band
2000
Vinyl and paint on aluminium,
179.5 × 57.8 × 15 cm
Courtesy the artist and
Lisson Gallery, London

YINKA SHONIBARE

Vacation 2000
Wax-printed cotton textile,
fibreglass
Dimensions variable
Courtesy the artist and
Stephen Friedman Gallery,
London

BOB AND ROBERTA SMITH

STOP IT WRITE NOW! 2000
Wall painting
Dimensions variable
Courtesy Anthony Wilkinson
Gallery, London

GILLIAN WEARING

Prelude 2000
DVD for single-screen
projection, black and white
with sound
Courtesy the artist and
Maureen Paley / Interim Art,
London

RICHARD WRIGHT

Wall Painting 2000
Site-specific installation,
Tate Britain
Courtesy the artist /
The Modern Institute, Glasgow

BIOGRAPHIES

OLADÉLÉ AJIBOYÉ BAMGBOYÉ

Spells for Beginners
1994/2000, video still.
Courtesy the artist

was born in Nigeria, in 1963.
He studied for a BSc in
Chemical Engineering at
Strathclyde University, Glas-
gow, from 1981 to 1985. He was
a founding member of Street
Level Gallery in Glasgow and
an Arts Council Trainee Exhi-
bition Curator at Cambridge
Darkroom Gallery. He completed
an MA in Media Fine Art Theory
and Practice at the Slade
School of Fine Art, London
(1996–8). Solo exhibitions
have taken place at Culturgest,
Lisbon (1998); Stadtische
Galerie im Buntentor, Bremen
(1998); Art Pace, San Antonio
(1999); Helsinki City Art
Museum (2000); Thomas Erben
Gallery, New York (2000);
Witte de With, Rotterdam
(2000). Group exhibitions
include *Freedom*, Amnesty
International Glasgow groups,
Art Gallery & Museum, Kelvin-
grove, Glasgow, and tour
(1995–7); *In/Sight African*
Photographers 1940–Present,
Solomon Guggenheim Museum,
New York (1996); Documenta X,
Kassel (1997); Johannesburg
Biennale (1997); *Dak'art 98 –*
Dakar Beinnale (1998), *go*
away, Royal College of Art,
London (1999); Laboratorium,
Antwerp Open (1999). He lives
and works in London.

MICHAEL CRAIG-MARTIN

Working drawing for *Store*
Room 2000, computer-generated
image (detail). Courtesy
the artist and Waddington
Galleries

was born in Dublin in 1941.
He grew up and was educated in
the United States, studying
Fine Art at Yale University
School of Art and Architec-
ture. He moved to Britain on
completion of his studies in
1966. His first one-person
exhibition was at the Rowan
Gallery, London, in 1969. He
has exhibited in numerous solo
and group exhibitions across
the world and in 1989 a major
retrospective of his work was
organised at the Whitechapel
Art Gallery, London. He taught
at Goldsmiths College, London,
from 1974 to 1988, returning
there as Millard Professor
of Fine Art in 1993. More
recently, he curated the tour-
ing exhibition *Drawing the*
Line: Reassessing Drawing Past
and Present, Southampton City
Art Gallery and tour (1995);
participated in *Un Siècle de*
sculpture Anglaise, Galerie
Nationale du Jeu de Paume,
Paris (1996); represented
Great Britain at the São Paulo
Biennial (1998); and exhibited
a site-specific installation
in *ModernStarts: Things*,
Museum of Modern Art, New York
(1999). He was a trustee of
the Tate Gallery for ten years
(1989–99). He continues to
live and work in London.

MARTIN CREED was born in
Wakefield, Yorkshire, in 1968
and studied at the Slade
School of Fine Art, London,
from 1986 to 1990. His solo
exhibitions have included:
Galerie Analix B & L Polla,
Geneva (1995); Galleria Paolo
Vitolo, Milan (1997); *Work*
No.203, The Portico, London
(curated by Ingrid Swenson,
1999); Cabinet Gallery, London
(1999); Mark Foxx Gallery, Los
Angeles (1999), *Martin Creed*

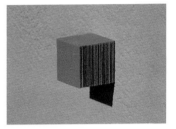

Work No.74: as many 1"
squares as are necessary
cut from 1" masking tape
and piled up, adhesive
sides down, to form a
1" cubic stack 1992, masking
tape, polystyrene, paper,
cardboard. Courtesy the
artist and Cabinet, London

Works, Southampton City Art
Gallery (2000); Gavin Brown's
enterprise, New York (2000);
Work No.225, Times Square,
New York (commissioned by the
Public Art Fund, 2000); *Work*
No.232, Art Now, Tate Britain,
London (2000). Group exhibi-
tions include: *Conceptual*
Living, Rhizome, Amsterdam
(1994); *Fuori Fase*, Viafarini,
Milan (1995); *Life/Live*, Musée
d'Art de la Ville de Paris
(1996–7); *Dimensions Variable*,
British Council touring
exhibition (1997); *Speed*,
Whitechapel Art Gallery,
London (1998); *everyday*,
Eleventh Sydney Biennale
(1998); *Getting the Corners*,
Or Gallery, Vancouver (1999);
DON'T WORRY, Chelsea & West-
minster Hospital, London

(2000); *British Art Show 5*, National Touring Exhibition (2000). He has performed with the band owada in numerous venues across the world. He lives and works in London.

TACITA DEAN was born in

Bubble House 1999, 16mm film. Courtesy the artist and Frith Street Gallery, London

1965, in Canterbury, Kent. After graduating from Falmouth School of Art with a BA in 1988, she won a Greek Government Scholarship to the Supreme School of Fine Art in Athens for one year. Dean subsequently completed an MA at the Slade School of Fine Art, London, in 1992. She has had many solo exhibitions including: Art Now, Tate Gallery, London (1996); Witte de With Center for Contemporary Art, Rotterdam (1997); ICA, Philadelphia, with US tour (1998); Dundee Contemporary Art (1999); De Pont Foundation, Tilburg (1998);

Museum für Gegenwartskunst, Basel (2000); as well as regular exhibitions at Frith Street Gallery, London, and Marian Goodman Gallery, New York. She has also participated in numerous group exhibitions, for example: *Mise en Scene*, Institute of Contemporary Arts, London (1994); *British Art Show 4*, National Touring Exhibition (1995–6); *Container '96*, Copenhagen; The Turner Prize, Tate Gallery, London (1998); *Amateur/Liebhaber*, Kunstmuseum, Kunsthallen, and Hasselblad, Göthenberg (2000); *Mixing Memory & Desire*, Kunstmuseum Luzerne (2000). Dean also participated in the Scriptwriters Lab at the Sundance Institute, Utah, in 1997. Her book *Teignmouth Electron* was published in 1999 by Book Works in association with the National Maritime Museum, London. She lives and works in London.

JEREMY DELLER was born in 1966. He studied at the Courtauld Institute of Art, London, from 1985 to 1988 for a BA in Art History and then from 1991 to 1992 at Sussex University for an MA in Art History. His solo exhibitions include: *The Search for Bez*, Weekenders, London, curated by Matthew Higgs (1994); *At Home*,

The Maypole, Padstow, Cornwall, 1 May 2000, from *An introduction to Folk archive*

Cabinet Gallery, London (1996); *The Uses of Literacy*, Norwich Art Gallery (1997); Art Concept, Paris (1998); *Unconvention*, Centre for Visual Arts, Cardiff (1999). He has also participated in many group exhibitions, such as: *Co-operators*, Southampton City Art Gallery (1996); *The Butterfly Ball*, Stringfellows Nightclub, London, with Peter Stringfellow and Alan Kane (1996); *Lovecraft*, CCA, Glasgow (1997); *Voiceover*, National Touring Exhibitions (1998); *Presumed Innocent*, CAPCC, Bordeaux (2000); *Democracy*, Royal College of Art, London (2000). He has organised many projects such as the Acid Brass Live Concerts, Tribal Gathering, Luton (1997) and Queen Elizabeth Hall, London (1997). Ongoing series of work include: *Advanced Capitalism* (1998 onwards) and *Now it is Allowable*, collaborations with Karl Holmquist

based on the work of Emmanuel Swedenborg. Deller has produced publications such as *The Uses of Literacy*, published by Book Works, London (1999) and *Life is to Blame for Everything*, to be published by Salon 3, London (2000). He lives and works in London.

WILLIAM FURLONG was born

William Furlong constructing *Thosel* in his studio, London, June 2000

in Surrey in 1944. He studied at Guildford School of Art from 1960 to 1965 and then at the Royal Academy Schools, London, 1965–8. His work was included in *New Contemporaries*, Tate Gallery, London (1967), and in 1973 he founded *Audio Arts Magazine*. He has exhibited widely in the UK and his work has also been included in a number of exhibitions in Australia, Europe and North America. Solo and group exhibitions include

Artists' Soundworks, Sydney
Biennale (1981); *Objects &
Spaces* in *The Sculpture Show*,
Hayward Gallery, London
(1983); *Absences/Presences*,
Atellergemeinschaft, Münster
(1996); Life/Live, Musée d'Art
Modern de la Ville de Paris
(1997); *Spoken For/Spoken
About*, in *Voice Over*, a series
of commissioned works for Arts
Council of England National
Touring Exhibitions (1998);
International Radio Promenade,
Lake Konstanz, in *Kunst in der
Stadt 2*, Kunstverein, Bregenz
(1998); *Walls of Sound*,
commissioned by Sculpture at
Goodwood (1998); *Sound Garden*,
commissioned by the Serpentine
Gallery, London (1998); and *An
Imagery of Absence*, Imperial
War Museum, London (1998).
Furlong lives and works in
London and is currently Direc-
tor of Research at Wimbledon
School of Art.

LIAM GILLICK was born in
1964 in Aylesbury, Bucking-
hamshire. He studied at
Hertfordshire College of Art
(1983–4). In 1987 he completed
a BA at Goldsmiths College,
London. Gillick has received
many solo exhibitions, for
example: *Documents* (with Henry
Bond), Karsten Schubert,
London (1990); *The What If?
Scenario*, Robert Prime, London
(1996); *Discussion Island*,

*Discussion Island Development
Screen* 1997, aluminium,
Plexiglas, fittings. Courtesy
the artist and Corvi-Mora

Basilico Fine Art, New York
(1997); Le Consortium, Dijon
(1997); *Revision*, CNAC Villa
Arson, Nice (1998); *David*,
Frankfurter Kunstverein (1999);
and co-ordinated a number of
projects including *The Trial
of Pol Pot* (with Philippe Par-
reno) at Le Magasin, Grenoble
(1998). He has also partici-
pated in numerous group exhi-
bitions such as *No Man's Time*,
CNAC, Villa Arson, Nice (1991);
Brilliant!, Walker Art Centre,
Minneapolis, Minnesota (1995);
Life/Live, Musée d'Art Moderne
de la Ville de Paris (1996–7);
Documenta X, Kassel (1997).
His books include *Erasmus is
Late* (1995) and *Discussion
Island/Big Conference Centre*
(1997). His critical writings
have appeared in many publica-
tions. He lives and works in
London and New York.

DOUGLAS GORDON was born

List of Names since 1990, text
on wall at Kunstverein Hannover
1998. Courtesy the artist and
Lisson Gallery, London

in 1966 in Glasgow, where he
continues to live and work.
He attended Glasgow School of
Art from 1984 to 1988 and
completed his studies in 1990
at the Slade School of Art,
London. His first solo exhibi-
tion, *24 Hour Psycho*, was
shown at Tramway, Glasgow and
Kunst-Werke, Berlin (1993).
Since then, his work has been
exhibited extensively in
Britain and internationally.
Exhibitions include:
Migrateur, Musée d'Art Moderne
de la Ville de Paris (1993);
Dirv Gallery, Tel Aviv (1998);
Dia Center for the Arts,
New York (1999); and *Feature
Film*, Atlantis Gallery, London
(1999). Gordon has partici-
pated in the biennials at
Kwang Jung, Korea (1995), Lyon
(1996), Sydney (1996), Berlin
(1998) and Venice (1997,
1999), where, in 1997, he was
awarded the Premio 2000. Other

group exhibitions include:
Prospeckt '93, Kunsthalle,
Frankfurt (1993); *Points de
vue: Images d'Europe*, Centre
Georges Pompidou, Paris
(1994); *Life/Live*, Musée d'Art
Moderne de la Ville de Paris
(1996); *The Turner Prize*
(winner), Tate Gallery, London
(1996); *Pictura Britannia*,
Museum of Contemporary Art,
Sydney (1997); Guggenheim
Museum Hugo Boss Prize,
Guggenheim SoHo, New York
(1998); Kunstverein Hannover
(1998); *Beauty – 25th Anniver-
sary*, Hirshhorn Museum and
Sculpture Garden, Washington
DC (1999); *Sheep and Goats*,
Musée d'Art Moderne de la
Ville de Paris (2000); and
Tate Liverpool (2000).

GRAHAM GUSSIN was born in

Spill 1999, 16mm black and
white film. Installation
at Aarhus Kunstmuseum, 1999.
Artist's collection

London in 1960. He studied at
Middlesex Polytechnic (1981–5)
and then at Chelsea School of

Art, London (1989–90). He has held solo exhibitions at Chisenhale Gallery, London (1993); Primo Piano, Rome (1993, 1995); Cohen Gallery, New York (1994); Lotta Hammer, London (1996, 1998); Gianluca Collica, Cantania (1996); Camden Arts Centre, London (1997); Tate Gallery, London (1998); and Aarhus Kunstmuseum, Denmark (1999). His work has been included in group shows worldwide. Selected exhibitions include: *New Identities*, Camden Arts Centre, London (1989); *Walter Benjamin's Briefcase*, Oporto (1993); *Wonderful Life*, Lisson Gallery, London (1993); *Wall to Wall*, National Touring Exhibitions, Leeds City Art Gallery (1994); *Institute of Cultural Anxiety*, Institute of Contemporary Arts, London (1994); *Perfect Speed*, Macdonald Stewart Art Centre, Canada and Contemporary Art Museum, University of South Florida, Tampa (1995); *The Meaning of Life, Video Programme*, CCA, Glasgow and The Art Node Foundation, Stockholm (1996); *Material Culture*, Hayward Gallery, London (1997); *Europarte*, Fondazione Bevilacqua La Masa, Venice Biennale (1997); *Art Document '98*, Hiroshima (1998); *The Tarantino Syndrome*, Künstlerhaus Bethanien, Berlin (1998); Melbourne Biennale (1999); and

The British Art Show 5, National Touring Exhibitions (2000). He lives and works in London.

SUSAN HILLER was born in

Witness 2000, mixed media sound installation. Installed at The Chapel, Golborne Rd, London 2000 (detail). Commissioned by Artangel, London. Courtesy the artist

Tallahassee, Florida, in 1942 and has lived and worked in London since 1973. She studied at Smith College, Massachusetts, and Tulane University, New Orleans. She has had numerous solo exhibitions in Great Britain as well as in Europe, Australia and the United States, including: Institute of Contemporary Arts, London (1986); Sigmund Freud Museum, London (1994); Tate Gallery Liverpool (1996); Institute of Contemporary Arts, Philadelphia (1998); Delfina Gallery, London (1999). Recent group exhibitions

include: *Rites of Passage*, Tate Gallery, London (1995); *Now/Here*, Louisiana Museum, Denmark (1996); Sydney Biennale (1997); *Out of Action: Between Performance and the Object 1949–1979*, Museum of Contemporary Art, Los Angeles (1998); *The Muse in the Museum*, Museum of Modern Art, New York (1999); *The British Art Show 5*, National Touring Exhibitions (2000): *Amateur/Liebhaber*, Kunstmuseum, Kunsthallen, and Hasselblad, Göthenberg (2000). Hiller was awarded a Guggenheim Fellowship in 1998. Her publications include: *After the Freud Museum* (Book Works, 1995); *Thinking about Art: Conversations with Susan Hiller* (Manchester University Press, 1996); and *Witness* (Artangel, 2000). She has recently curated *Dream Machines*, an international group exhibition for National Touring Exhibitions. *Witness* was commissioned by Artangel in 2000 and originally shown in a disused chapel in west London.

JAKI IRVINE was born in Dublin in 1966. After graduating from the National College of Art and Design, Dublin, in 1989, she completed a Masters Degree in Fine Art at Goldsmiths College, London,

Eyelashes 1996, 8mm film still. Courtesy the artist and Frith Street Gallery, London

in 1994. Her solo exhibitions include *Margaret Again*, Anthony Wilkinson Fine Art, London (1995); *Eyelashes*, Project Arts Centre, Dublin (1996); *Another Difficult Sunset*, Frith Street Gallery, London (1997); *'Fledermaus she cried…', Yet on the Other Hand*, Staatliche Kunsthalle, Baden-Baden (1998); and *The Hottest Sun, The Darkest Hour – A Romance*, Douglas Hyde Gallery, Dublin (1999). She exhibited in the Venice Biennale in 1995 and 1997. Other group exhibitions include *EKKER*, City Arts Centre, Dublin, and Perth Institute of Contemporary Art (1991); *A State of Great Terror*, Douglas Hyde Gallery, Dublin (1992); *Wonderful Life*, Lisson Gallery, London (1993); *4 Projects*, Frith Street Gallery, London (1995); *Pandemonium*, ICA, London (1996); *Now Here*, Louisiana Museum of Art, Denmark (1996); *A small*

shifting sphere of serious culture, Atheneum Cultural Centre, Dijon (1997); *White Noise*, Kunsthalle, Bern (1998); and *Space*, Witte de With, Rotterdam (1999). She lives and works in Italy and London.

ALAN JOHNSTON was born in

Untitled 2000, pencil, charcoal, titanium white, beeswax, MDF. Courtesy the artist and Jack Tilton Gallery, New York

1945. He studied at Edinburgh College of Art from 1964 to 1969 and completed an MA in 1972 at the Royal College of Art, London. He was awarded a DAAD Scholarship to Düsseldorf (1972–3). He has received numerous solo exhibitions since 1973, including: Konrad Fischer, Düsseldorf (1973); Museum of Modern Art, Oxford (1978); Shimada Gallery, Yamaguchi (1985); The Living Art Museum, Reykjavik (1988); Shimada Gallery, Tokyo (1994);

Inverleith House, Royal Botanic Garden, Edinburgh (1995); Jack Tilton Gallery, New York (1998); Gallery Erckle, Tblisi (1999); Gangurrin, Reykjavik (2000). He has participated in many group exhibitions, such as: *276 Miles from Here*, Goethe Institute, London (1974); *Contemporary Art*, Fruitmarket, Edinburgh (1981); *Drawing*, Hayward Gallery, London (1982); *Scottish Art*, Scottish National Gallery of Modern Art, Edinburgh, and Barbican, London (1989); *11 Cities Architectural Project*, Leeuwarden (1990); *Odyssey*, The Carnegie Museum, Pittsburgh, Pennsylvania (1996); *A Passion for Painting*, The Whitney Museum, New York (1997); *29 x 6h*, Dia Genese Art Foundation, Düsseldorf (1999); *Two Cube Project*, with Shinichi Ogawa, I.A.V. Akiyoshidai (1999). He has also curated projects such as *Walk On, Six Scottish Artists*, Jack Tilton Gallery, New York (1991); and *Thomas Struth: Photographs from Two Edinburgh Collections*, Reiach & Hall, Edinburgh (1997). He lives and works in Edinburgh.

ALAN KANE was born in Nottingham in 1961. He studied at Canterbury College of Art. He has both had solo shows and

Banner for Art Exhibition at the Church Hall, Hutton, Lancashire 2000

worked in collaboration, such as *Alan Kane and Simon Periton Guild the Lily*, The Heritage Centre, London (1993); *Strange Spectacle* with Simon Periton, The Sportsverbander, Frankfurt (1994); *Butterfly Ball* with Jeremy Deller and Peter Stringfellow, Stringfellows, London (1995); *Taste (Sense and Sensibility)*, Transmission Gallery, Glasgow (1995); *Sublimely, Misguided Tours*, Norwich Art Gallery and various sites (1997–9); *Wines & Spirits*, Murray Arms, London (1998). His group exhibitions have included: *W.M. Football Karaoke*, Portikus, Frankfurt (1994); *Weekender 4*, Imprint 93, Cubitt Street, London (1994); *Co-Operators*, Southampton City Art Gallery (1996); *Kiss This*, Focal Point Gallery, Southend (1996); *Networking Art by Post and by Fax*, National Touring Exhibitions (1997); *To Be Continued…* New Art Gallery, Walsall

(1999); *Limit Less*, Galerie Krinzinger, Vienna (1999). He lives and works in London.

MARK LEWIS was born in

The Pitch 1998, 35mm film, transferred to DVD, shown on a monitor. Installation at Stedelijk Van Abbemuseum 1999. Courtesy Patrick Painter Editions, Vancouver

Hamilton, Canada, in 1958. He has received many solo exhibitions, for example: UBC Fine Arts Gallery, Vancouver (1994); Tramway, Glasgow (1996); Patrick Painter Inc., Los Angeles, California (1997, 1999, 2000); *Attitudes*, Geneva (1999); Institute of Visual Arts, Milwaukee (1999); Site Gallery, Sheffield (2000); Museum of Modern and Contemporary Art, Geneva (2000); National Gallery of Canada, Ottawa (2000). He has participated in numerous group exhibitions, including: *Pour la suite de monde*, Musée d'Art Contemporain, Montreal (1992);

The Human Condition: Hope and Despair at the End of the Century, The Spiral Building, Tokyo (1994); *Les Contes de fées se terminent bien*, FRAC Haute Normandie, Rouen (1996); *Printemps de Cahors*, Cahors (1997); *Cinema! Cinema!, The Cinematic Experience*, Stedelijk Van Abbemuseum, Eindhoven (1999); *Wouldn't it be Nice*, Gallerie Montevideo, Amsterdam (2000). Lewis is a Principal Lecturer in Research at Central Saint Martins College of Art and Design, London. He lives and works in London.

HILARY LLOYD was born in

Ewan 1995. Installation view, Cultural Instructions, London 1995. Courtesy the artist

Yorkshire in 1964. She attended Newcastle-upon-Tyne Polytechnic in 1984–7, where she studied Fine Art. Her work has been shown in group exhibitions in Europe and New York including *Making People*

Disappear, Cubitt Gallery, London (1993); *Imprint 93/ Cabinet Gallery*, Cabinet Gallery, London (1994); *Life/ Live*, Musée d'Art Moderne de la Ville de Paris and Centro Cultural de Belém, Lisbon (1996); *Alex Katz, Hilary Lloyd, Chris Moore, Andy Warhol*, Gavin Brown's Enterprise, New York (1996); *Lovecraft*, CCA, Glasgow, and South London Gallery, London (1997); *Assuming Positions*, ICA, London (1997); *Accelerator*, Southampton City Art Gallery and Arnolfini, Bristol, (1998); *SuperNova*, Stedelijk Museum Bureau, Amsterdam (1998); *The British Art Show 5*, National Touring Exhibitions (2000). Her first solo exhibition took place at Cultural Instructions, London (1995) and has been followed by subsequent shows at Casco, Utrecht (1997), Chisenhale Gallery, London (1999) and Frankfurter Kunstverein as part of the series *Kino der Dekonstruktion* (2000). She lives and works in London.

BRIGHID LOWE was born in Newcastle-upon-Tyne in 1965. Having studied Fine Art at Reading University in 1985–9, she completed a Postgraduate Diploma in Sculpture at the Slade School of Fine Art,

I Saw Two Englands Breakaway 1996–7, 225 books, 450 Perspex mounts, C-type on flexibase (detail). Courtesy the artist

London (1991). *Sequence*, held at The Photographers' Gallery, London, in 1992, was Lowe's first solo exhibition. Since then, she has exhibited in *Collective Joy for the Masses*, Hales Gallery, London (1993); *Truth–Hallucination*, John Hansard Gallery, Southampton (1997); *Inserts, Garden History, The Journal of the Garden History Society, artists' commissions in the academic journals*, The Laboratory at the Ruskin, Oxford (1998). She has exhibited widely in group exhibitions across the UK including *BT New Contemporaries*, ICA, London, Arnolfini, Bristol, and tour (1989–90); *Wonderful Life*, Lisson Gallery, London (1993); *Something's Wrong*, The Tannery, London (1994); *England's Glory*, Ikon Gallery, Birmingham, commission for Witley Court, Worcestershire (1995);

The Mule, one-off newspaper publication and internet site (1997); and *Post Neo-Amateurism*, Chisenhale Gallery, London. More recently, her work has been seen at Het Consortium, Amsterdam, in the exhibition *and..and..and..and* (1999). In 1998, she received a Paul Hamlyn Foundation Award for Artists. She lives and work in London.

SARAH LUCAS was born in

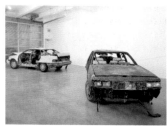

Life's a Drag Organs 1998, 2 burnt cars, cigarettes, glue. Collezione Prada

1962 in London. She studied at the Working Men's College, London (1982–3), at the London College of Printmaking (1983–4) and at Goldsmiths College, London (1984–7). Her solo exhibitions include: *Penis Nailed to a Board*, City Racing, London (1992); *The Shop* (with Tracey Emin), London (1993); *Where's my Moss*, White Cube, London

(1994); Portikus, Frankfurt (1996); *The Law* and *Bunny Gets Snookered*, Sadie Coles HQ, London (1997); *The Old In Out*, Barbara Gladstone Gallery, New York; *Beautiness*, Contemporary Fine Art, Berlin (1999); *Beyond the Pleasure Principle*, Freud Museum, London (2000). She has participated in many group exhibitions, for example, *Freeze*, PLA Building, London (1988); *Young British Artists II*, Saatchi Collection, London (1993); ARS 95, Helsinki (1995):*Brilliant!*, Walker Art Centre, Minneapolis (1995); *Masculin/Feminin*, Musée National d'Art Moderne, Paris (1996); *Material Culture*, Hayward Gallery, London (1997); *Sensation*, Royal Academy of Arts, London (1997); *Real Life: New British Art*, Japanese tour (1998); *This is Modern Art*, Billboard commissioned by Channel 4, London (1999). She lives and works in London.

JULIAN OPIE was born in London in 1958 and attended Goldsmiths College, London, from 1979 to 1982. His first one-person show was in 1984 at the Lisson Gallery, London, where he has continued to show regularly. Other solo exhibitions include: Institute of Contemporary Arts, London

Male nude, reclining? 2000, vinyl. Courtesy the artist and Lisson Gallery, London

(1985); Kunsthalle, Bern (1991); Hayward Gallery, London (1993); Kunstverein Hannover (1994); Gallery Bob van Orsouw, Zürich (1996, 1999); and Barbara Thumm Gallery, Berlin (1997, 1999). In 1987 he took part in Documenta 8 in Kassel, and he has participated in the biennials in Paris (1985), Sydney (1990, 1998) and Venice (1993) and the triennials in Milan (1986) and New Dehli, India (1997–8). Other group exhibitions include: *Correspondentie Europa*, Stedelijk Museum, Amsterdam (1986); *Objectives: The New Sculpture*, Newport Harbor Art Museum, Newport Beach, California (1990); *Between Cinema and a Hard Place*, Tate Modern, London (2000); and Kunstsammlung Nordhein-Westfalen, Düsseldorf (2000). Permanent works for public commissions include: *Cinq Matiments de Banlieue*, FRAC Aquitaine, Cloître des Annonciades, Bordeaux (1995); *Imagine you are moving*,

Heathrow Airport, Terminal 1, commissioned and funded by BAA plc as part of the BAA Art Programme in association with the Public Art Development Trust (1997); and *Two Cars Three People Two Buildings a Cow and a Sheep*, Wolfsberg (2000). He continues to live and work in London.

YINKA SHONIBARE was born

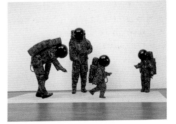

Vacation 2000, wax-printed cotton textile, fibreglass. Courtesy the artist and Stephen Friedman Gallery, London

in 1962 in London where he now lives and works. He grew up in Nigeria but returned to England to study at the Byam Shaw School of Art, London, and then at Goldsmiths College, London. Shonibare has exhibited internationally in: Tenth Biennial of Sydney (1996); *Sensation*, Royal Academy of Arts, London, and tour (1997); *Secret Victorians*, Arts Council Touring Exhibition (1999);

In the Midst of Things, Bournville Village, Birmingham (1999); *Mirror's Edge*, Bild-Museet, Umeå, and tour (1999); *Heaven*, Kusthalle Düsseldorf, and Tate Gallery Liverpool (1999); *Missing Link*, Kunstmuseum Bern (1999); *Kunstwelten im Dialog*, Museum Ludwig, Cologne (1999); *South Meets West*, Accra, Ghana, and Kunsthalle Bern (2000); *Laboratory, Continental Shift*, Bonnefantenmuseum, Maastricht (2000); Biennale de Lyon (2000); and *Age of Influence: Reflections in the Mirror of American Culture*, Museum of Contemporary Art, Chicago (2000). Recent solo exhibitions include: Stepehn Friedman Gallery, London (1996, 1998); *Alien Obsessives*, Mum *Dad and the Kids*, Tablet, the Tabernacle, London, and Norwich Art Gallery (1998); *Diary of a Victorian Dandy*, site-specific project commissioned by InIVA for the London Underground (1998); *Dressing Down*, Ikon Gallery, Birmingham and tour (1999); and Camden Arts Centre, London (2000). In 1998, Shonibare received the Paul Hamlyn Foundation Award for visual artists. Yinka Shonibare is represented by Stephen Friedman Gallery in London.

BOB AND ROBERTA SMITH

STOP IT WRITE NOW! 1999.
Installation at National
Museum of Contemporary Art,
Oslo, commissioned by
Beaconsfield 1999

is the assumed name of Patrick
Brill, born in London in 1963.
He graduated from the Univer-
sity of Reading in 1985 and
completed his fine art train-
ing with an MA at Goldsmiths
College, London (1991–3).
Since 1994, Bob and Roberta
have held three exhibitions at
Anthony Wilkinson Gallery,
London (1994, 1996, 1999) and
have shown at Arnolfini, Bris-
tol (1997–8) and in *Don't Hate
Sculpt*, Chisenhale Gallery,
London (1997). Their work has
also been exhibited in *The Man
Whose Head Expanded*, Cooper
Union School of Arts and Sci-
ence, New York (1989); at
Pieroli 2000, New York (1998);
at Galerie Carbone, Turin
(1999). Group exhibitions
include: *New Contemporaries*,
Camden Arts Centre, London
(1994); *Karaoke*, South London
Art Gallery (1995); *Bank TV*,

Bank, London (1996); *Urban
Legends*, Staatliche Kunsthalle
Baden-Baden (1997); *Camouflage
2000*, Gallery Praz-Delaval-
lade, Paris (1998); *Do All
Oceans Have Walls*, Künstler-
haus, Bremen (1998); *STOP IT
WRITE NOW!*, National Museum of
Contemporary Art, Oslo (1999);
Peace, Migros Museum, Zürich
(1999); and *Landscape*, British
Council Touring Exhibition
(2000). Bob and Roberta Smith
are based in London.

GILLIAN WEARING was born

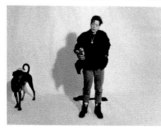

Prelude 2000, video still.
Maureen Paley / Interim Art

in Birmingham in 1963. She
studied for a BA in Fine Art
at Goldsmiths College
(1987–90), after completing a
B.Tech in Art and Design at
Chelsea School of Art. She has
had many solo exhibitions,
including: City Racing, London
(1993); Maureen Paley/Interim
Art, London (1994, 1996, 1999);
Western Security, Hayward
Gallery, London (1995);

Le Consortium, Dijon (1996);
Kunsthaus Zürich (1997);
10–16, Chisenhale Gallery,
London (1997); Jay Gorney
Modern Art, New York (1997);
Centre d'Art Contemporain,
Geneva (1998); De Vleeshal,
Middelburg (1999); Gorney
Bravin + Lee, New York (2000).
She has also participated in
many group exhibitions, such
as *Uncertain Identity*, Galerie
Analix B & L Polla, Geneva
(1994): *British Art Show 4*,
National Touring Exhibitions
(1995); *Brilliant!*, Walker Art
Centre, Minneapolis, Minnesota
(1995); *Private View*, Bowes
Museum, Durham (1996); *The
Turner Prize* (winner), Tate
Gallery, London (1997); *Sensa-
tion*, Royal Academy of Art,
London (1997); *Get Together*,
Kunsthalle, Vienna (1999);
Sixth International Istanbul
Biennial, Turkey (1999). She
lives and works in London.

RICHARD WRIGHT was born
in London in 1960. He studied
painting at Edinburgh College
of Art (1978–82) and completed
his training with an MA at
Glasgow School of Art (1993–5)
His first solo exhibition was
at Transmission Gallery,
Glasgow, in 1994. Solo shows
have been held at California
Institute of the Arts, Los
Angeles (1994); Inverleith

Work from The Drawing Centre,
New York, 1999, gouache.
Courtesy the artist /
The Modern Institute, Glasgow

House, Edinburgh (1999); and
BQ, Cologne (1999). His work
has been exhibited widely in
group shows, including: *Pure
Fiction*, Intermedia Gallery,
Glasgow (1993); *New Art in
Scotland*, Centre for Contempo-
rary Art, Glasgow, and
Aberdeen City Art Gallery
(1994); *30 Secs + Title*, Art
Gallery of Ontario, Toronto
(1995); *Sugarhiccup*, Tramway,
Glasgow (1996); *Live/Life*,
Musée d'Art Moderne de la
Ville de Paris (1996); *Pictura
Britanica*, Museum of Contempo-
rary Art, Sydney (1997); *Mani-
festa 2*, Luxembourg (1998);
Surfacing Contemporary Drawing
at the ICA, London (1998), The
Drawing Centre, New York
(1999); *Creeping Revolution*,
Foksal Gallery, Warsaw (1999);
The British Art Show 5,
(2000); and *Amateur*, Gothen-
burg Museum of Modern Art
(2000). He lives and works in
Glasgow.

SUPPORTING TATE

Tate relies on a large number of supporters – individuals, foundations, companies and public sector sources – to enable it to deliver its programme of activities both on and off its gallery sites. This support is essential in order to acquire works of art for the Collection, present education, outreach and exhibition programmes, care for the Collection in storage and enable art to be displayed, both digitally and physically, inside and outside Tate. Your funding will make a real difference and enable others to enjoy Tate and its Collections, both now and in the future. There are a variety of ways in which you can help support Tate and also benefit as a UK or US taxpayer. Please contact us at:

The Development Office
Tate, Millbank, London SWIP 4RG
Call: 020 7887 8000
Fax: 020 7887 8738

American Fund for the Tate Gallery
1285 Avenue of the Americas (35th fl)
New York
NY 10019
Call: 001 212 713 8497
Fax: 001 212 713 8655

DONATIONS

Donations, of whatever size, from individuals, companies and trusts are welcome, either to support particular areas of interest, or to contribute to general running costs.

Gift Aid Through Gift Aid, you are able to provide significant additional revenue to Tate for gifts of any size, whether regular or one-off, since we can claim back the tax on your charitable donation. Higher rate tax payers are also able to claim additional personal tax relief. A Gift-Aid Donation form and explanatory leaflet can be sent to you if you require further information.

Legacies and Bequests Bequests to Tate may take the form of either a specific cash sum, a residual proportion of your estate or a specific item of property such as a work of art. Tax advantages may be obtained by making a legacy in favour of Tate; in addition, if you own a work of art of national importance you may wish to leave it as a direct bequest or to the Government in lieu of tax. Please check with Tate when you draw up your will that it is able to accept your bequest.

American Fund for the Tate Gallery The American Fund for the Tate Gallery was formed in 1986 to facilitate gifts of works of art, donations and bequests to Tate from United States residents. It receives full tax exempt status from the IRS.

MEMBERSHIP PROGRAMMES

Members and Fellows Individual members join Tate to help provide support for acquisitions for the Collection and a variety of other activities, including education resources, capital initiatives and sponsorship of special exhibitions. Benefits vary according to level of membership. Membership costs start at £24 for the basic package with benefits varying according to level of membership. There are special packages for supporters of Tate Liverpool and Tate St Ives.

Patrons Patrons are people who share a keen interest in art and are committed to giving significant financial support to Tate on an annual basis, specifically to support acquisitions. There are four levels of Patron: Associate Patron (£250), Patrons of New Art (£500), Patrons of British Art (£500) and Patrons Circle (£1000). Patrons enjoy opportunities to sit on acquisition committees, special access to the Collection and entry with a family member to all Tate exhibitions.

Tate American Patrons Residents of the United States who wish to support Tate on an annual basis can join the American Patrons and enjoy membership benefits and events in the United States and United Kingdom. Single membership costs $1000 and double membership $1500. Please contact the American Fund for the Tate Gallery for further details.

Corporate Membership Corporate Membership at Tate Liverpool and Tate Britain, and support for the Business Circle at Tate St Ives, offers companies opportunities for exclusive corporate entertaining and the chance for a wide variety of employee benefits. These include special private views, free admission to paying exhibitions, out-of-hours visits and tours, invitations to VIP events and talks at the workplace. Tate Britain is only available for entertaining by companies who are either Corporate members or current Gallery sponsors.

Founding Corporate Partners
Until the end of March 2003, companies are also able to join the special Founding Corporate Partners Scheme which offers unique access to corporate entertaining and benefits at Tate Modern and Tate Britain in London. Further details are available on request.

Corporate Investment Tate has developed a range of imaginative partnerships with the corporate sector, ranging from international interpretation and exhibition programmes to local outreach and staff development programmes. We are particularly known for high-profile business to business marketing initiatives and employee benefit packages. Please contact the Corporate Fundraising team for further details.

Charity Details Tate is an exempt charity; the Museums & Galleries Act 1992 added the Tate Gallery to the list of exempt charities defined in the 1960 Charities Act. The Friends of the Tate Gallery is a registered charity (number 313021). The Tate Gallery Foundation is a registered charity (number 295549).

TATE BRITAIN CORPORATE MEMBERS

Partner Level
BP
Merrill Lynch
Prudential plc

Associate Level
Alliance & Leicester plc
Cantor Fitzgerald
Channel Four Television
Credit Suisse First Boston
Drivers Jonas
Freshfields
Global Asset Management
Goldman Sachs International
Hugo Boss
Lazard Brothers & Co., Limited
Linklaters & Alliance
Manpower PLC
Morgan Stanley Dean Witter
Nomura International plc
Nycomed Amersham plc
Publicis Ltd
Robert Fleming & Co. Limited
Schroders
Simmons & Simmons
The EMI Group
UBS AG

FOUNDING CORPORATE PARTNERS

AMP
BNP Paribas
CGU plc
Clifford Chance
Energis Communications
Freshfields
GKR
GLG Partners

Goldman Sachs
Lazard Brothers & Co., Limited
Lehman Brothers
London & Cambridge Properties Limited
London Electricity, EDF Group
PaineWebber
Pearson plc
Prudential plc
Reuters
Rolls-Royce plc
Railtrack PLC
Schroders
UBS Warburg
Wasserstein Perella & Co., Inc

TATE COLLECTION SPONSOR

Carillion plc
 Paintings Conservation
 (1995-2000)

TATE BRITAIN FOUNDING SPONSORS

BP
 Campaign for the Creation
 of Tate Britain
 (1998–2000)
 New Displays (1990–2000)
 Tate Britain Launch (2000)

Ernst & Young
 Cézanne (1996)
 Bonnard (1998)

TATE BRITAIN BENEFACTOR SPONSORS

Channel Four Television
 The Turner Prize
 (1991–2000)

Prudential plc
 Grand Tour (1996)
 *The Age of Rossetti,
 Burne-Jones and Watts:
 Symbolism in Britain
 1860–1910* (1997)
 The Art of Bloomsbury
 (1999)

TATE BRITAIN MAJOR SPONSORS

Aon Risk Services Ltd
in association with ITT London
& Edinburgh
 *In Celebration: The Art of
 the Country House* (1998)

Glaxo Wellcome plc
 Turner on the Seine (1999)

Magnox Electric
 Turner and the Scientists
 (1998)

Morgan Stanley Dean Witter
 Constructing Identities
 (1998)
 John Singer Sargent (1998)
 *Visual Paths: Teaching
 Literacy in the Gallery*
 (1999)

Sun Life and Provincial
Holdings plc
 *Ruskin, Turner & the Pre-
 Raphaelites* (2000)

Tate & Lyle PLC
 Tate Friends (1991–2000)

TATE BRITAIN SPONSORS

AT&T
 Piet Mondrian (1997)

British Telecommunications plc
 Tate Britain Launch (2000)

The Guardian/The Observer
 Jackson Pollock (1999)
 Media Sponsor for the Tate
 2000 launch (2000)

Hiscox plc
 Tate Britain Members' Room
 (1995–2000)

TATE BRITAIN: DONORS TO THE CENTENARY DEVELOP-MENT CAPITAL CAMPAIGN

Founder
Heritage Lottery Fund

Founding Benefactors
Sir Harry and Lady Djanogly
Sir Edwin and Lady Manton
Lord and Lady Sainsbury of
Preston Candover
The Wolfson Foundation

Major Donors
The Annenberg Foundation
Ron Beller and Jennifer Moses
Alex and Angela Bernstein
Ivor Braka
The Clore Foundation
Maurice and Janet Dwek
Bob and Kate Gavron
Sir Paul Getty KBE
Mr and Mrs Karpidas
Peter and Maria Kellner
Catherine and Pierre Lagrange
Ruth and Stuart Lipton
William A. Palmer
John and Jill Ritblat
Barrie and Emmanuel Roman
Charlotte Stevenson
Tate Gallery Centenary Gala
The Trusthouse Charitable
Foundation
David and Emma Verey
Clodagh and Leslie Waddington
Sam Whitbread

Donors
The Charlotte Bonham Carter
Charitable Trust
Giles and Sonia Coode-Adams
Thomas Dane
The D'Oyly Carte Charitable
Trust
The Dulverton Trust
Friends of the Tate Gallery
Alan Gibbs
Mr and Mrs Edward Gilhuly
Helyn and Ralph Goldenberg
Pehr and Christina
Gyllenhammar
Jay Jopling
Howard and Linda Karshan
Anders and Ulla Ljungh

Lloyds TSB Foundation for
England and Wales
David and Pauline
Mann-Vogelpoel
Sir Peter and Lady Osborne
The P F Charitable Trust
The Polizzi Charitable Trust
Mrs Coral Samuel CBE
David and Sophie Shalit
Mr and Mrs Sven Skarendahl
Pauline Denyer-Smith
and Paul Smith
Mr and Mrs Nicholas Stanley
The Jack Steinberg
Charitable Trust
Carter and Mary Thacher
Dinah Verey
Gordon D. Watson
The Duke of Westminster OBE TD DL
Mr and Mrs Stephen Wilberding
Michael S. Wilson
*and those donors who wish to
remain anonymous*

TATE COLLECTION

Founders
Sir Henry Tate
Sir Joseph Duveen
Lord Duveen
The Clore Foundation

Benefactors
American Fund for the
Tate Gallery
Gilbert and Janet de Botton
The Friends of the
Tate Gallery
Heritage Lottery Fund
National Art Collections Fund
National Heritage Memorial
Fund

The Patrons of British Art
The Patrons of New Art

Major Donor
Robert Lehman Foundation, Inc.

Donors
Howard and Roberta Ahmanson
Lord and Lady Attenborough
Mr Tom Bendhem
Robert Borgerhoff Mulder
The British Council
Mrs John Chandris
The Clothworkers Foundation
Edwin C Cohen
Daiwa Anglo-Japanese
Foundation
Judith and Kenneth Dayton
Mr Christopher Foley
The Gapper Charitable Trust
The Gertz Foundation
Great Britain Sasakawa
Foundation
HSBC Artscard
Mr and Mrs Michael
Hue-Williams
Idlewild Trust
The Japan Foundation
The Kessler Family Re-Union
Mr Patrick Koerfer
The Henry Moore Foundation
Peter and Eileen Norton,
The Peter Norton Foundation
Mr David Posnett
The Radcliffe Trust
Mr Simon Robertson
Mrs Jean Sainsbury
The Scouloudi Foundation
The Stanley Foundation Limited
Mr and Mrs A Alfred Taubman
Mr and Mrs Leslie Waddington
*and those donors who wish to
remain anonymous*

Reproduced by kind permission of copyright holders:

Taeko Bamgboyé; Oladélé Ajiboyé Bamgboyé; Beaconsfield, London; Cabinet, London; Sadie Coles HQ, London; Tomaso Corvi-Mora; Michael Craig-Martin; Martin Creed; Tacita Dean; Jeremy Deller; Todd Eberle; Foksal Gallery, Warsaw; Stephen Friedman Gallery, London; Frith Street Gallery, London; William Furlong; Liam Gillick; Barbara Gladstone Gallery, New York; Hugo Glendinning; Sculpture at Goodwood; Douglas Gordon; Graham Gussin; Susan Hiller; Institute of Contemporary Art, Philadelphia; Jaki Irvine; Alan Johnston; Alan Kane; Christopher Kern; David Lambert; Larry Lame; Marcus Leith; Mark Lewis; Lisson Gallery; Hilary Lloyd; Brighid Lowe; Sarah Lucas; Roman Mensing; The Modern Institute, Glasgow; Patrick Painter Editions, Vancouver; Maureen Paley/ Interim Art, London; Poul Pederson/Ole Hein Pederson; Richard Okon; Julian Opie; John Riddy, London; Yinka Shonibare; Steve Shrimpton, John Hansard Gallery, Southampton; Bob and Roberta Smith; Simon Starling; Waddington Galleries, London; Jean Wainwright; Gillian Wearing; Westfälischer Kunstverein, Münster; Stephen White; Anthony Wilkinson Gallery; Richard Wright; Raymond Zabaowsky

STOP IT WRITE NOW! by Bob and Robert Smith was originally commissioned by Beaconsfield for *British Links* at the National Museum of Contemporary Art, Oslo in June 1999

Spill by Graham Gussin was made possible with financial assistance from Aarhus Kunstmuseum, Denmark
Director of Photography: Vron Harris
Production: Christine Kretschmer

Consultation Filter by Liam Gillick was commissioned by the Westfälsicher Kunstverein, Münster